POSTCARD HISTORY SERIES

Ridgewood

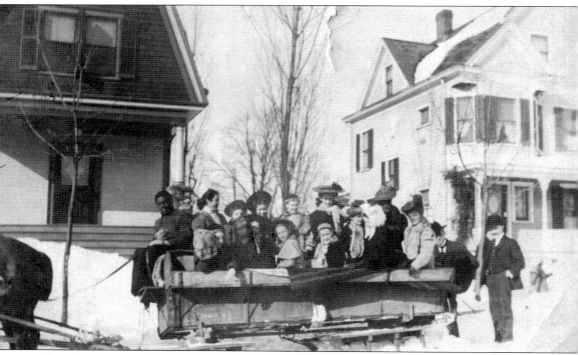

'Tis the season! In this 1901 postcard, we are greeted with 15 delightful members of Ridgewood society, all bundled up against the chill of a bright winter day. Several inches of snow surround the group, but all gathered seem undeterred in their plans to enjoy the mounds of snow that surround them. (Courtesy of the Ridgewood Historical Society.)

FRONT COVER: Taken at the corner of North Broad Street and Ridgewood Avenue, this postal shows what is now known as Station Plaza East, known for the iconic steeple clock. The businesses shown include Wisely Realty Company, Gordon & Forman Real Estate, and Plaza restaurant, which has a huge sign for an American Red Cross fundraiser next to it. Today, businesses occupy the building. (Courtesy of the Ridgewood Historical Society.)

BACK COVER: Grab your rods and reels! Fishing is a favorite pastime among the citizens of Ridgewood, just as it is in much of America, and with both the Saddle River and the Ho-Ho-Kus Brook available, Ridgewood provides the sportsman with ample opportunities for leisure. This card shows a dapper gentleman casting his line into the Ho-Ho-Kus Brook. (Courtesy of the Ridgewood Historical Society.)

POSTCARD HISTORY SERIES

Ridgewood

M. Earl Smith with the Ridgewood Historical Society
Introduction by Dacey Latham

ARCADIA
PUBLISHING

Copyright © 2017 by M. Earl Smith with the Ridgewood Historical Society
ISBN 978-1-4671-2714-1

Published by Arcadia Publishing
Charleston, South Carolina

Printed in the United States of America

Library of Congress Control Number: 2017936182

For all general information contact Arcadia Publishing at:
Telephone 843-853-2070
Fax 843-853-0044
E-mail sales@arcadiapublishing.com
For customer service and orders:
Toll-Free 1-888-313-2665

Visit us on the Internet at www.arcadiapublishing.com

To the citizens of Ridgewood, young and old:
may the history of your home be a guiding light in its future

CONTENTS

ACKNOWLEDGMENTS

Every time I write a volume for Arcadia, the work gets easier. This is a testament to the great minds that work for the publisher, whose dedication to their craft is unrivaled in the publishing business. Erin Vosgien, who has been a wonderful sounding board for the many ideas I have for volumes about my favorite towns along the Eastern Seaboard, must be the first person thanked. I also must thank Caroline Anderson, whose editorial eye and calm disposition are a port in the storm that is writing a book. Leigh Scott, Adam Kidd, and especially Megan Petrie have done an incredible amount of work promoting my works, and for that, I thank them.

Special thanks go to Dacey Latham of the Ridgewood Historical Society, who spent several hours in the cold with me as I scanned its collection for use in this volume.

Special thanks go to the following people at the University of Pennsylvania: Peter Stallybrass, John Pollack, R. Scott Hanson, Deborah Burnham, Yvie Fabella, and especially Melissa Jensen, who saw within me what I didn't see in myself and challenged me to use it. Thanks also go to my friends Nicole Fibbert, Will Dickens, Savannah Swearingen, Maggie Rymsza, Breanna Himschoot, and Mariam Aisset.

Finally, I wish to dedicate this volume to my children. You guys are destined to achieve more than I could ever have dreamed, and there are not enough adjectives in the English language to describe how proud I am of you. I love you guys, and I hope I do whatever I can to make your lives better.

INTRODUCTION

Ridgewood is a very special place. It has an interesting history and is presently a great place to live. In fact, many of the residents today are descendants of the early settlers in the area, and more often than not, those who grow up in Ridgewood and leave for college and careers return when it is time to bring up a young family.

From the Prospect Ridge in Hackensack to the ridge in Ridgewood lies a large fertile plain with small rivers and brooks running through it. The early settlers, made up of English, Dutch, and French, together formed a farming and trading area known as Paramus Valley. At the center, they established a Dutch Reformed church, a house, a blacksmith shop, and a store. The farmers flourished, as the soil was fertile, and they were content.

By 1735, they had built a sandstone brick church and a small schoolhouse. During the Revolutionary War, a few skirmishes were fought in the area around the church, which served as headquarters for the local military, a hospital, a courthouse, and a prison during the war. As time passed, the congregation grew, and in 1800, it built a larger church using some of the original sandstone. The church, known as the Old Paramus Church, stands proudly today overlooking the busy highway.

After the Civil War, the community we know today as Ridgewood grew rapidly. The advent of the railroad was a major factor in the growth, with businessmen commuting daily into New York and returning home to their beautiful homes on the west side. The flu and diphtheria epidemics in urban areas, especially Brooklyn, made the village appealing to families looking for a beautiful and healthy place to live. Many built summer homes here before they became permanent residents.

As the town grew, it became necessary to build our own high school. There was a question as to whether to build it of wood or brick. The women of the town were most emphatic that it be brick and stone. They prevailed, and today, the 1894 building houses the administrative offices. This was the same year the village was incorporated as Ridgewood.

The downtown flourished around the train station. Over the years, three hotels and a variety of stores for food, clothing, drugs, and hardware lined Ridgewood Avenue and the side streets. The 20th century saw continued expansion of the commercial area down Maple Avenue and along Godwin and Franklin Avenues. Several denominations of churches were built, and an airport was even once located in the area known today as the Lawns, a development of small homes built after World War II. It was not until the 1950s that Ridgewood grew more diverse with the establishment of the Jewish Community Center on Oak Street.

In 1957, when Dorothy came to live in Ridgewood, the town was as we described it, with easy parking, a large selection of all kinds of stores that suited the budgets of the whole town, a beautiful library, and a municipal pool.

Over the years since, the makeup of the stores has changed as large malls have been built in the county and many independent stores have left. We now have 40 restaurants, eight banks, several branches of large chains, and a few independent shops. No longer do buses provide transportation around town, but you can call a taxi. In the various neighborhoods around town, the many homes dating from the 19th century are sought-after residences, especially on the west side of town.

Ridgewood remains a beautiful town with everything a person could want or need: beautiful homes, great schools, a fine hospital, a strong community government, and services such as the fire department and the public library, as well as many outstanding civic and cultural organizations.

—Dacey Latham, with Dorothy Anne Pangburn
Ridgewood Historical Society

One

WINDING ROADS
STREETS AND LANES
OF RIDGEWOOD

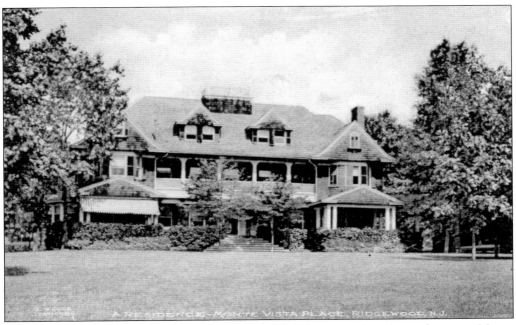

This 1905 postcard, published by stationer E.W. Cobb, shows a rather elegant home on Monte Vista Place, which is now known as Monte Vista Avenue. This was once the home of Francis B. Hiler's amateur radio station 28Q. To the west is North Monroe Street, to the east is the Amtrak rail line, to the south is Ridge Road, and to the north is Woodland Avenue. (Courtesy of the Ridgewood Historical Society.)

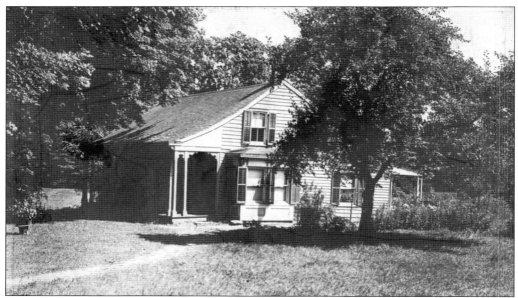

Before 1970, this simple home occupied the vast lot at 522 North Maple Avenue. A single-story, shuttered home, this house and the property it resided on gave way to Winthrop Manor Apartments. Built in 1970, these apartments (which sit just north of downtown Ridgewood) offer housing for locals and commuters to New York, a mere 30 minutes away. (Courtesy of the Ridgewood Historical Society.)

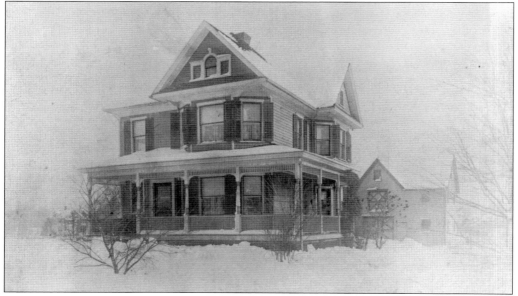

Upon purchasing two lots for $400 in 1893, James Garret and Rachel Catherine Hopper built this home. James ran a coal delivery business in nearby Wortendyke and was also responsible for installing a great many of the first sidewalks in Ridgewood. The couple were unique in that they were some of the last speakers of the Jersey Dutch dialect in the area. Their property is now in nearby Fairlawn and is occupied by an import car dealership. James passed away in 1920, Rachel in 1937. (Courtesy of the Ridgewood Historical Society.)

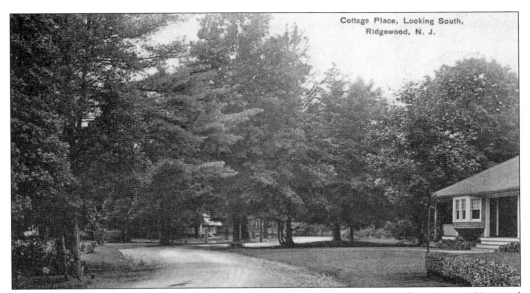

Cottage Place, Looking South, Ridgewood, N. J.

Located between North Walnut Street and North Maple Avenue, Cottage Place starts at Linwood Avenue and crosses Robinson Lane and Franklin Avenue before terminating at East Ridgewood Avenue between Rite-Aid and the building that holds Bookends Bookstore, a locale famous for its multiple celebrity signings. The Beech Street School, at 49 Cottage Place, is a Romanesque Revival building that was constructed in 1895. The building is now in the National Register of Historic Places. (Courtesy of the Ridgewood Historical Society.)

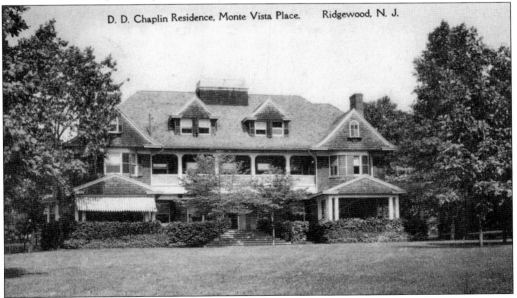

D. D. Chaplin Residence, Monte Vista Place. Ridgewood, N. J.

Located between Sheridan Terrace and Madison Place, Monte Vista Avenue starts in the east at Crest Road and crosses Heights Road and North Monroe Street before terminating at North Hillside Place in the west. This 1909 postcard was published by E.W. Cobb and shows the home, built by Rossiter and Wright, of Duncan Dunbar Chaplin. He was the grandson of John O'Brien, who piloted the schooners *Diligent* and *Hibernia* during the American Revolution. (Courtesy of the Ridgewood Historical Society.)

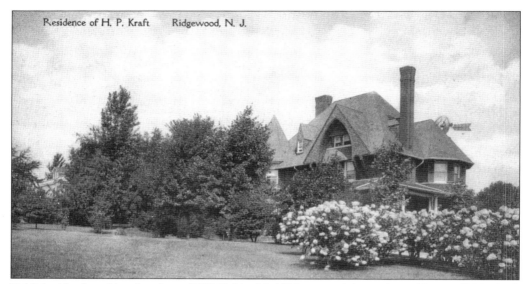

Published by famed local stationer E.W. Cobb, this 1909 postcard shows the residence of H.P. Craft on Godwin Avenue in Ridgewood. This springtime view entices the viewer with its blooming flowers and the lush, green grass that is visible even without the aid of color photography. The road's terminus is right before the train station, right around Wilsey Square, Garber Square, and West Ridgewood Avenue. The front of the card reads, "A Godwin Street Residence, Ridgewood, N.J." (Author's collection.)

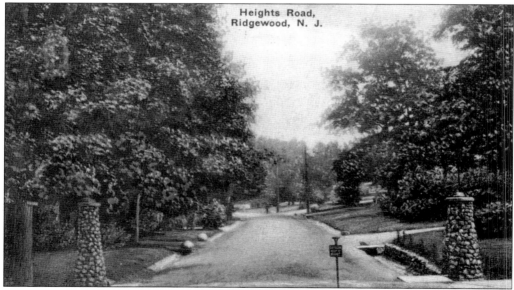

With two stone pillars standing as faithful sentries at its entrance, one cannot help but wonder what secrets lie down Heights Road. A sign reads "Go Slow. Keep to Right," perhaps giving Ridgewood one of its first traffic signs. The Heights area developed between 1892 and 1930, with most of the homes on the street built in the Tudor Revival and Colonial Revival styles. The homes, while not monochromatic in any sense of the word, do share similar sizes and shapes, which is remarkable given the different number of architects who designed the residences in the area. (Author's collection.)

12

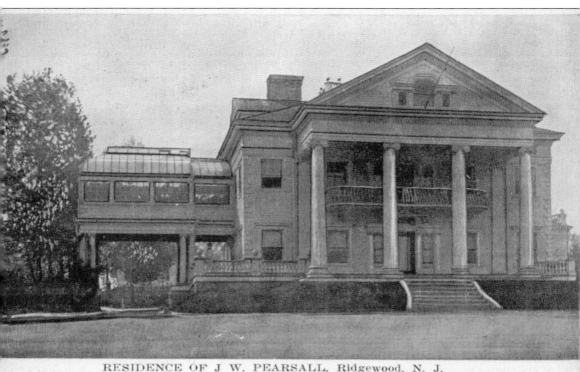

RESIDENCE OF J. W. PEARSALL, Ridgewood, N. J.

The J.W. Pearsall House was built in the Roman Revival style, although the attached second-floor sunroom gives it a very modern, almost Art Deco appearance. Pearsall was once the secretary of the National City Evangelizing Union, and he also served a six-year term as a member of the Ridgewood Fire Department between 1912 and 1918. He was born in New York on October 17, 1839, and died in Ridgewood on June 23, 1918. Aside from wholesaling butter for 20 years, Pearsall also managed the Domestic Sewing Machine Company for nearly two decades. His affiliations with nearly half a dozen religious and charitable societies left him fondly remembered at the time of his death. (Courtesy of the Ridgewood Historical Society.)

Starting at Godwin Avenue, close to the downtown core, and running into Glen Rock and beyond, Lincoln Avenue serves as both a hub of business and a nexus for the residential neighborhoods of Ridgewood and the surrounding cities. The route, which also serves as New Jersey Route 69, serves as the home for such landmarks as the Ridgewood Christian Reformed Church. The Ackerman House at 252 Lincoln Avenue (shown here) is in the National Register of Historic Places. The front of this 1910 postcard, a selection of springtime blooms next to residential homes, was printed by stationer E.W. Cobb and text on the back reads, "Lincoln Avenue Residences. Ridgewood, N.J." (Author's collection.)

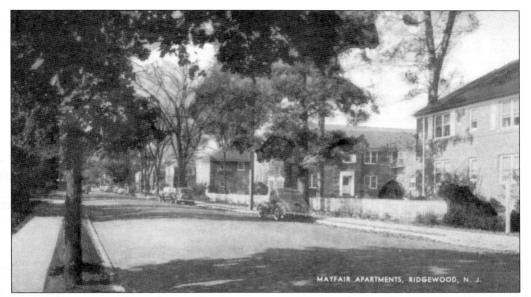

This 1944 specimen shows the Mayfair Apartments, on East Ridgewood Avenue in Ridgewood. A tariff was placed on postcards imported from Germany in the years preceding World War I, and this, in combination with the seizure of German business interests in America, led to the decline of German postcards in America. This card, printed by the Mayrose Company of New York City, is a fine example of one such printing. As for the Mayfair Apartments, they are no longer standing. (Author's collection.)

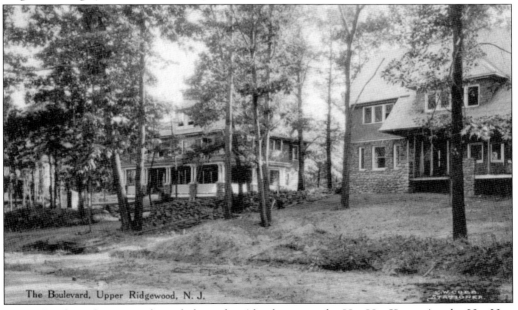

Upper Boulevard runs southward along the ridge between the Ho-Ho-Kus train, the Ho-Ho-Kus Brook, and Hillcrest Road. It crosses Glenwood Road, Fairmount Road, Barrington Road, West Glen Avenue, and a small branch of the Ho-Ho-Kus Brook before terminating in the south at Hillcrest Road. The home values along its route routinely top a million dollars. (Courtesy of the Ridgewood Historical Society.)

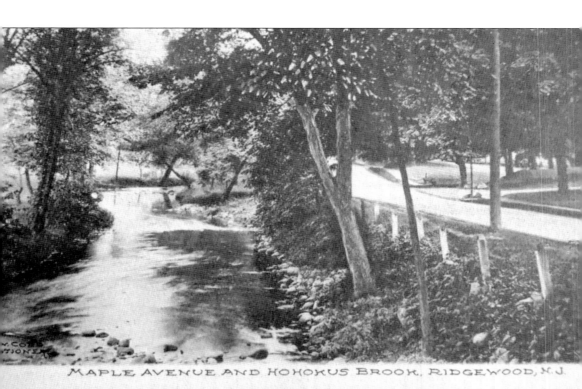

MAPLE AVENUE AND HOHOKUS BROOK, RIDGEWOOD, N.J.

This gorgeous view shows North Maple Avenue as it runs next to Ho-Ho-Kus Brook. The avenue is home to landmarks such as the Bethlehem Lutheran Church, the Graydon Pool, the Ridgewood Public Library, and, at 570 North Maple Avenue, the Rathbone-Zabriskie House. Built in 1790, this large Colonial-style home was added to the National Register of Historic Places in 1983. Today, North Maple Avenue also serves as a part of New Jersey Route 507. The front of this card, published by stationer E.W. Cobb, reads, "Maple Avenue and Hohokus Brook, Ridgewood, N.J." (Author's collection.)

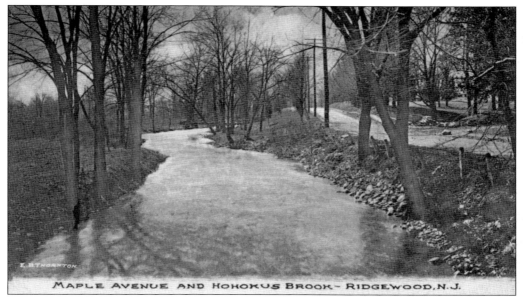

MAPLE AVENUE AND HOHOKUS BROOK~RIDGEWOOD, N.J.

Maple Avenue runs almost parallel to the winding path of the Ho-Ho-Kus Brook. Published by local stationer E.B. Thornton, this card shows the scenic route on a short stretch of the path. North Maple Avenue starts at the Franklin Turnpike, crosses the brook, and then runs side by side with it for a good distance before the book diverges into Graydon Pond to flow southeast away from the center of town. Along North Maple Avenue are Granny's Attic, Enterprise Rent-A-Car, the police department, and the public library. (Courtesy of the Ridgewood Historical Society.)

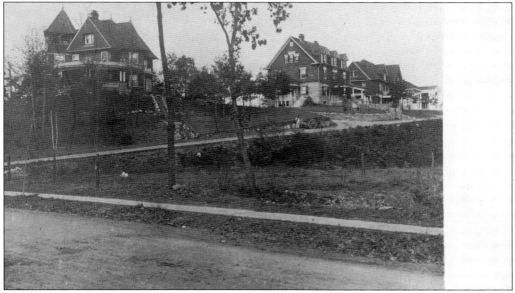

Born from the intersection of Madison Place and Ridge Road, Corsa Terrance runs the mere distance of a block before terminating at West Ridgewood Avenue. Several apartments are available on Corsa Terrace, including those listed by local realtors such as Re/Max and Terri O'Connor Realtors. Many of the old homes here have either been repurposed as apartments or torn down so that new apartments could be constructed. (Courtesy of the Ridgewood Historical Society.)

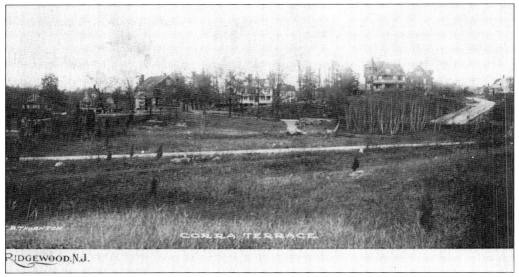

There is no reference to a "Corra Terrace" anywhere in Ridgewood, so it is safe to assume that this is an error on the part of postcard publisher E.B. Thornton. The area in question appears to be Corsa Terrace. Rebecca W. Hawes, of 36 Corsa Terrace, is credited with opening a private music school in Ridgewood sometime after 1879, when Amelia E. Barr's private school closed for good. Hawes ran the school out of Teddy Terhune's furniture store on the corner of Ridgewood Avenue and South Oak Street. (Courtesy of the Ridgewood Historical Society.)

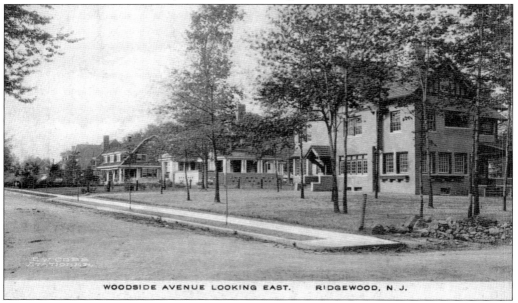

This 1912 image shows Woodside Avenue in a view looking east. Most homes on Woodside Avenue now sell for over seven figures. This was one of the few attempts to publish art cards, as opposed to simple photographs, by local stationer E.W. Cobb. The white border is also unique in Cobb cards. A message on the back reads, "A sample of Ridgewood's houses. Come down & see us." The front text reads, "Woodside Avenue Looking East. Ridgewood, N.J." (Author's collection.)

Dear my, all well at home. Gussie

The Methodist church is visible on the left side of this 1915 postcard giving a view of Prospect Avenue in Ridgewood. Published as part of a series of cards by W.A. Crooker, this view shows the road after the rise of the automobile but before the rise of paved streets. The Vanderbeck House, at 249 Prospect Street, was built around 1790 with bricks made of clay and straw. Harmanus and Abraham Vanderbeck built the home, which was placed in the National Register of Historic Places in 1983. (Courtesy of the Ridgewood Historical Society.)

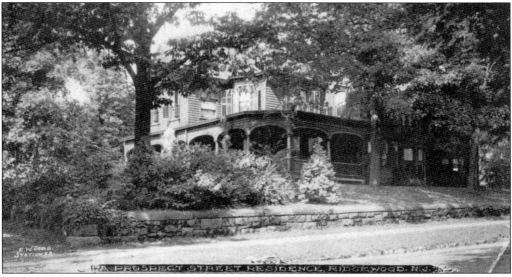

Departing from East Ridgewood Avenue, Prospect Street runs south for several miles before eventually crossing into Fair Lawn and becoming Prospect Avenue. Along with boxing in Our Lady of Mount Caramel Roman Catholic Church, Prospect Street plays home to Glen Rock Gurudwara, one of the first places of worship for Sikhs in northern New Jersey. (Courtesy of the Ridgewood Historical Society.)

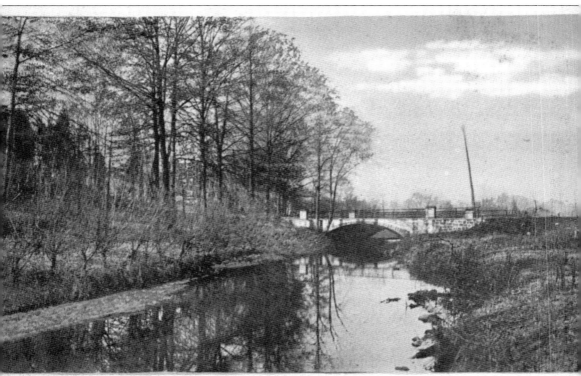

SPRING AVE., RIDGEWOOD, N. J.

Although this postal of the dirt roads of Spring Avenue was never used, it does contain a lengthy message on the back. The message reads, in part, "Dear M. Was surprised to hear that you had moved. I think you may like Scarsdale it is very nice up that way. Ma is not very strong & I don't think she might ever be again." The card goes on to invite the recipient to celebrate an aunt's golden wedding celebration. Finally, the sender writes, "This is the street we live on. The first is our house." (Courtesy of the Ridgewood Historical Society.)

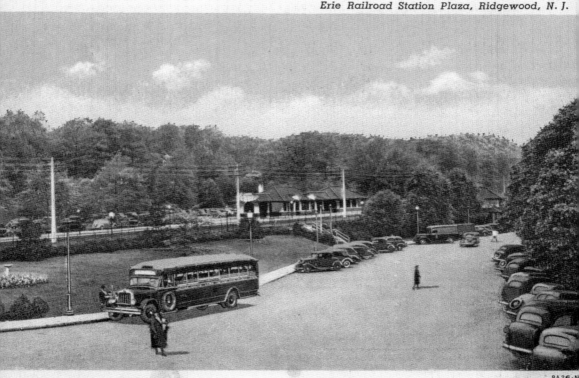

8A26-N

The Erie Railroad station at Ridgewood is shown in this 1916 postal. The station was new at the time, serving the commuting needs of Ridgewoodians in and out of New York City. This card was published by Ridgewood publisher William Crooker and is one of the earliest hand-colored examples to come from the area. The print on the card reads, "Erie Railroad Station Plaza, Ridgewood, N.J.," and the handwriting reads, "I heard you were to Ridgewood, did you see this station? Pa & Ma." (Author's collection.)

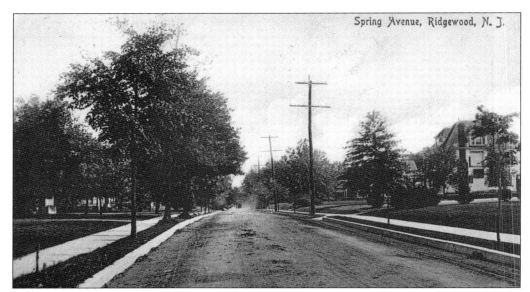

Starting in the west at Prospect Street, Spring Avenue crosses South Maple Avenue, Hope Street, South Irving Street, Brookside Avenue, South Van Dien Avenue, Circle Avenue, Kenilworth Road, and South Pleasant Avenue before terminating in a cul-de-sac just past Bergen Court. The Dunham Trail and Ho-Ho-Kus Brook also cross its path. The cul-de-sac comes just before the Saddle River in the east. (Courtesy of the Ridgewood Historical Society.)

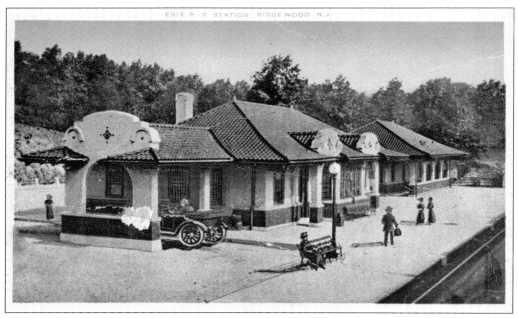

"Railroad station" is perhaps a bit of a misnomer, as the station serves most of the public transit needs in the Ridgewood area today. The station has bus connections for the 163, 164, 175, 722, 746, and 752 busses, although train passengers must walk two blocks to Van Neste Square to make the switch. Here is a back view of the station. Much like today, it rises above Godwin Avenue, which is consistently lined with automobiles on both sides. (Author's collection.)

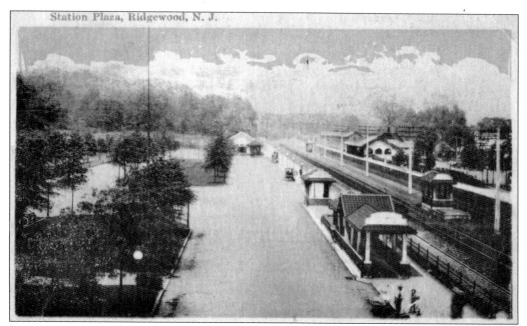

Station Plaza, Ridgewood, N. J.

This aerial shows a complete overview of the Erie Railroad station at Ridgewood. Both the Main Line and the Bergen County Line run through the station today, which is serviced by three sets of tracks and two platforms (one side platform and one island platform, although it used to be two side platforms). The station was listed in the National Register of Historic Places in 1984. (Courtesy of the Ridgewood Historical Society.)

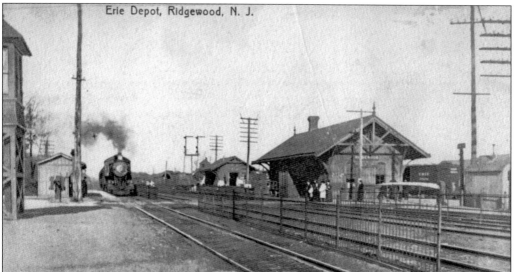

Erie Depot, Ridgewood, N. J.

In 2009, the Ridgewood Station, under the purview of the New Jersey Transit Authority, underwent a major renovation. Two high-rise platforms were installed with handicap access, as were new restroom facilities, new stairs, canopies, and lighting, along with curbside parking, accessible parking, sidewalks, and curb lighting. The upgrades made the station a far cry from the rustic view pictured on the front of this 1909 postcard. (Courtesy of the Ridgewood Historical Society.)

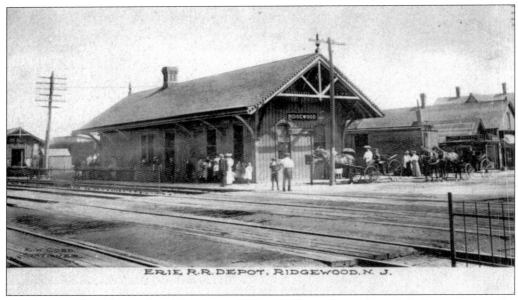

ERIE R.R. DEPOT, RIDGEWOOD, N. J.

Per the record on the National Register of Historic Places form, the original structure at the Ridgewood Station was a shelter consisting of a poured concrete foundation, redbrick exterior walls, stucco interior walls, concrete drip molding, 12-pane doors, Spanish tile roofing, painted signage, and a chimney. Baseboard heating was installed later, as were acoustic ceiling tiles and venetian blinds. (Courtesy of the Ridgewood Historical Society.)

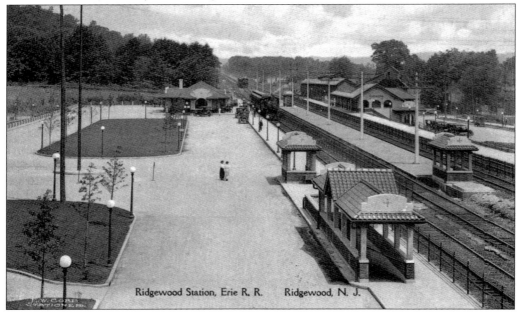

Ridgewood Station, Erie R. R. Ridgewood, N. J.

The Ridgewood Station is boxed in by Franklin Avenue to the north, Godwin Street to the west, and South Broad Street to the east. This area is known as Wisley Square. Also within the square are the Social Service Association, West Side Bagels & Deli, and, of course, the Septa and Amtrak customer service areas. Within one's line of sight are Van Nestle Park and the main village square. (Courtesy of the Ridgewood Historical Society.)

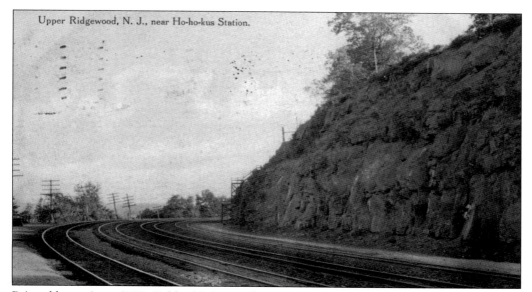

Printed by stationer E.W. Cobb, this image shows three sets of tracks near Ho-Ho-Kus Station in what was Upper Ridgewood. This card was mailed to a Mrs. Fred Powell of Washington, Connecticut, and the message reads, "Yours & Charlie's card received and we were glad to hear from you. Mama received a letter from you to-day and you have no doubt received her card advising you she would come up to Wash. Next Saturday. Wish I could only go with her. Rudy. R.J.D." (Author's collection.)

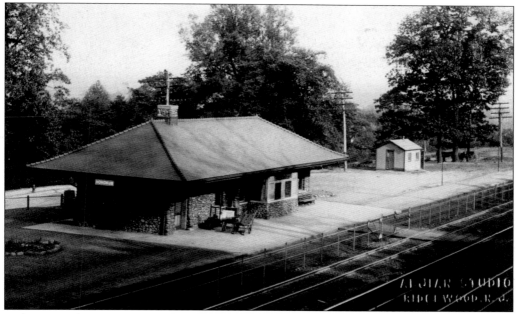

Before it was known as the Erie Railroad station, the Ridgewood Station was simply known as the depot. Today, the station offers three lines, with service to Suffern, Ho-Ho-Kus, Hoboken, and Glen Rock, among others. The station is one of seven in the state of New Jersey that is handicap accessible. The station code is 2315. Ridgewood Station is also a well-known transfer point, with both bus and further rail service available. (Author's collection.)

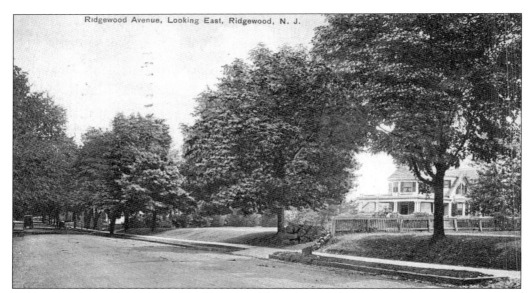

With wagons approaching in the distance visible, this pre-1907 postal shows a view of East Ridgewood Avenue, just outside the business district. Even with the rise of the automobile, most roads at the time were left unpaved, as radial tires did not become standard on automobiles until the 1930s. One thing that was paved, or at least was poured with concrete, was the sidewalks, which started to lace the streets of several suburban communities in this period. (Courtesy of the Ridgewood Historical Society.)

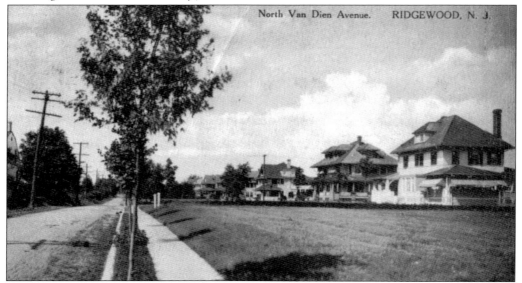

Intersecting with East Glen Avenue at Valleau Cemetery, North Van Dien Avenue runs south, crossing Meadowbrook Avenue, Linwood Avenue, Fairway Road, Colonial Road, Overbrook Road, Wyndemere Avenue, and Beverly Road, before becoming South Van Dien Avenue at East Ridgewood Road. Named after the famous Van Dien family, who are responsible for some of the oldest homes in the area, the road now plays host to both Benjamin Franklin Middle School and the Valley Hospital, a 451-bed emergency room facility that is scheduled to move to nearby Paramus—although a date has not been set. (Author's collection.)

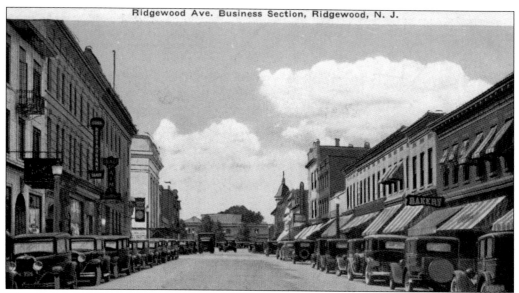

This 1910 view, printed by stationer E.W. Cobb, was taken farther from the downtown core on East Ridgewood Avenue. The carriages of the bourgeoisie can be seen lining the street sides of this once–dirt road. Electricity was expanding from the downtown core at this point, as evidenced by the five-crossed utility poles in frame. The lush greenery of the trees places this image in a period between summer and early fall. (Courtesy of the Ridgewood Historical Society.)

This undated, poorly produced c. 1920s postcard shows a private residence on Ridgewood Avenue. Before 1915, most postcards in the area were produced by the Paramus Valley Photographic Association. This gave Ridgewood a distinct advantage over most areas. Instead of having artists' renditions printed on the cards, most were instead taken with a Kodak 3-A postcard camera owned by E.W. Cobb. Cobb's family was in the stationery business as far back as 1840 in Hertford, England. Once the club disbanded due to World War I, the quality of the cards, like the one pictured here, declined. (Author's collection.)

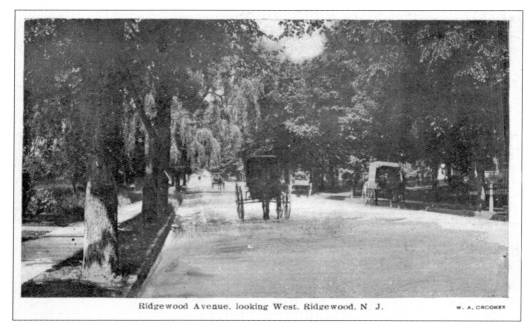

Ridgewood Avenue, looking West, Ridgewood, N. J.

The boundaries of West Ridgewood Avenue have been rather ambiguous for decades. Initially, it simply described the view if one were driving west on Ridgewood Avenue. However, in 1930 (24 years after this postal), Franklin Avenue, at least at the edge of downtown, was renamed West Ridgewood Avenue. Regardless, the horses pulling the carriages in this postal could not care less; a dirt road was a dirt road, regardless of where in Ridgewood it lay. (Author's collection.)

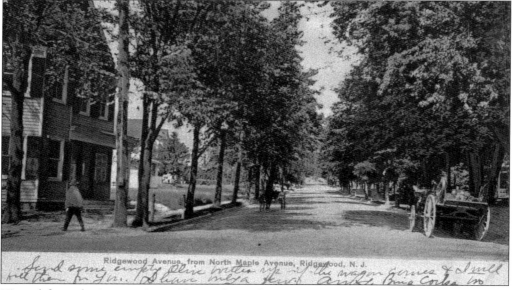

Ridgewood Avenue, from North Maple Avenue, Ridgewood, N. J.

Viewed from the intersection with North Maple Avenue, this watercolor postal shows a dirt version of Ridgewood Avenue. The multicolored leaves on the trees hint at a turning to fall for this sleepy New York bedroom community, as the dirt roads and wagons, despite being less than 20 miles from Manhattan, harken back to a simpler time. The front of the card reads, "Ridgewood Avenue, from North Maple Avenue, Ridgewood, N.J." (Author's collection.)

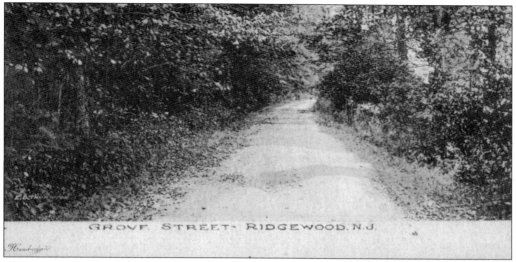

This hand-colored 1915 postal from E.B. Thornton shows Grove Street long before it became one of the main throughways in Ridgewood. Starting at Prospect Street in the west, Grove Street crosses both the Ho-Ho-Kus Brook and the Saddle River before terminating at Paramus Road. Along its route is the Temple Israel & Jewish Community Center as well as the Van Dien House. At 627 Grove Street, the Van Dien House was built in 1736, with improvements and additions continuing until 1770. Garret Van Dien built the house after purchasing a 520-acre plot in 1713 to farm. (Courtesy of the Ridgewood Historical Society.)

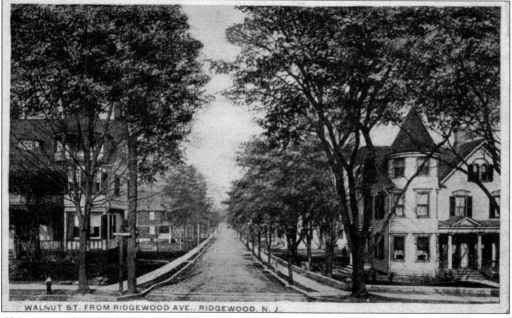

This postcard, published by E.B. Thornton in 1917, shows the intersection of Walnut Street and Ridgewood Avenue. In a little over 20 years, this section of town would evolve from shady residential streets to new, modern buildings that contributed to the growing commerce of the area. Today, the post office and Hillman Electric occupy the opposite corners of this part of town. The trees, sadly, are long gone. (Courtesy of the Ridgewood Historical Society.)

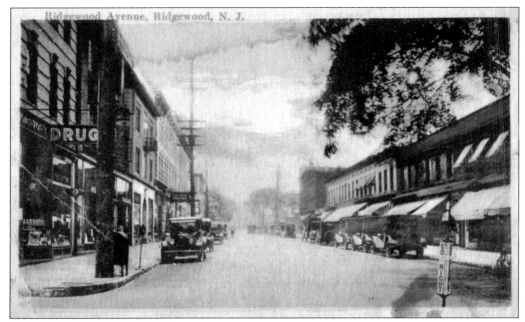

The white borders and hand coloring date this Ridgewood postcard to sometime in the 1920s, as do the roofed automobiles, which feature headlights. Visible in the center of the frame is one of the earliest traffic signs in Ridgewood. Instead of running on wires over the street, as they do now, these were often planted in the center of the road. A drugstore is visible on the left, and the front of the card reads, "Ridgewood Avenue, Ridgewood, N.J." (Author's collection.)

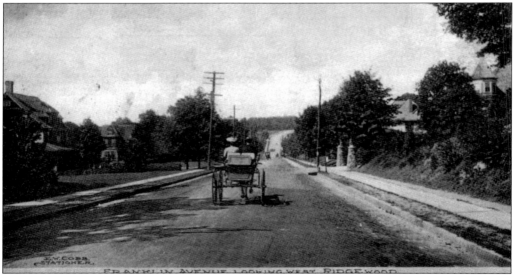

Starting at a wooded path in the east that crosses both the jogging trail and Ho-Ho-Kus Brook, Franklin Avenue is shown in a view looking west towards the center of town in this postcard published by stationer E.B. Cobb. Franklin Avenue crosses North Maple Avenue, Cottage Place, Oak Street, Chestnut Street, and the Ridgewood Rail Line before terminating at Garber Square in the west. Ben and Jerry's Ice Cream, A Mano Pies, and Baumgart's Café lie along its route. (Courtesy of the Ridgewood Historical Society.)

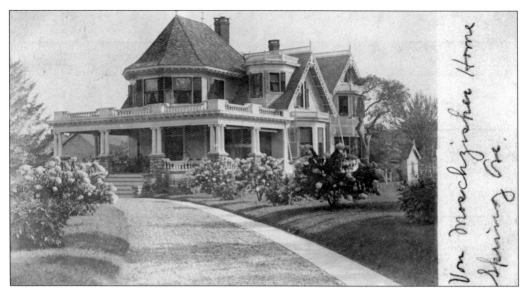

This pre-1907 postcard shows the Von Moschizisker House, which is in Ridgewood at 410 Spring Avenue. Built in 1897, it is of the Foursquare Colonial Revival style. F.A. Von Moschizisker built the home with funds he earned while working for the Erie Railroad. In 1911, he was elected to a term on the Ridgewood Board of Education. The chimney is unique in that it runs through the center of the house as opposed to along a side wall. The second-story balcony reaches over the front porch, and the home has hipped dormers and a hipped roof (not visible here). (Courtesy of the Ridgewood Historical Society.)

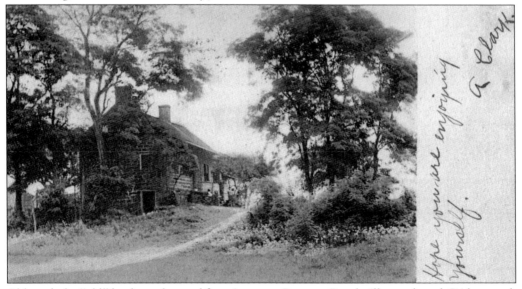

Although the "old" has been dropped from its name, Paramus Road still runs though Ridgewood. The road starts at New Jersey Route 161 in Paramus and runs north, passing Arcola Country Club, the Paramus Golf Course, Bergen Community College, and Orchard Hill Golf Course and crossing over several roads in both towns before terminating at New Jersey Route 17, which is part of the Garden State Parkway. The message on the card reads, "Hope you're enjoying yourself. A. Clay." (Courtesy of the Ridgewood Historical Society.)

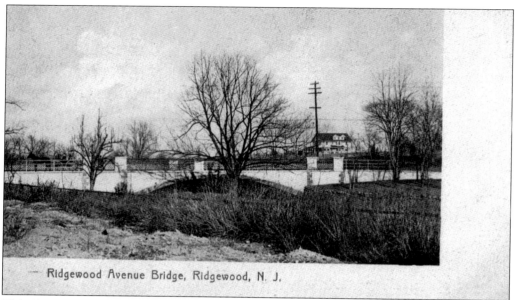

Ridgewood Avenue Bridge, Ridgewood, N. J.

This 1905 postcard shows the Ridgewood Avenue Bridge, running over the Ho-Ho-Kus Brook in Ridgewood. The full bloom of the trees seems to invite the viewer in for a swim, as countless generations of Ridgewoodians have done, although Graydon Pool, with its man-made controls and lifeguards, is now the choice local swimming spot. The handwriting reads, "Dearest Chet: Hello and goodbye. Loving by Mike." (Courtesy of the Ridgewood Historical Society.)

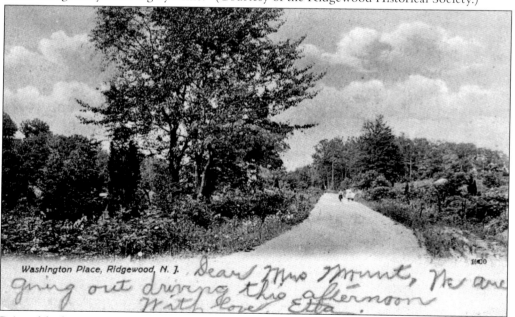

Washington Place, Ridgewood, N. J.

Printed before 1907, this wholesome card shows a trio of children walking down the dirt Washington Place. A short side road between West Ridgewood and Godwin Avenues, this road remained a small oasis of nature until, like most of Ridgewood, it was paved and absorbed into the downtown core. The road dead-ends at South Monroe Street and currently hosts George Washington Middle School, built in 1930. (Courtesy of the Ridgewood Historical Society.)

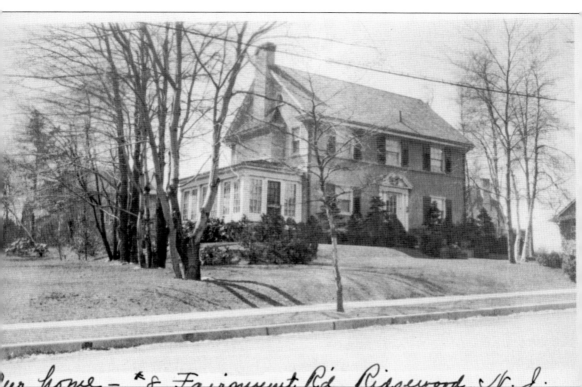

Our home — #8 Fairmount Rd. Ridgewood N. J.

Sitting close to the corner of Fairmont Road and Upper Boulevard, this family at 8 Fairmount Road must have felt fortunate to have their house on a postcard that they could mail to their friends. And although the house has been painted a striking blue-gray, it stands in much the same condition today as it did at the time of this photograph, including the spacious sunroom addition. Fairmount Road starts at Upper Boulevard in a residential section and terminates at north Monroe Street. The note on the card reads, "Our home— #8 Fairmount Rd, Ridgewood, N.J." (Courtesy of the Ridgewood Historical Society.)

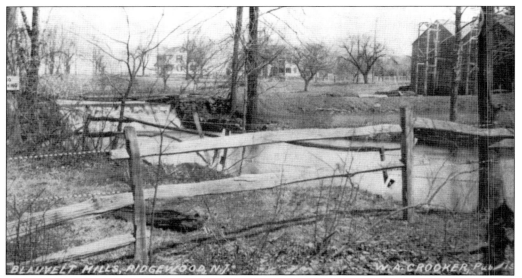

This tract of land, known as Blauvelt Mill, lies just north of the Jacob Zaborowski House on Paramus Road. The Blauvelt family has a long and storied history in Ridgewood. James Blauvelt ran a tavern at the head of the former Cherry Lane, now known as Lincoln Avenue. George Blauvelt was one of the first members of the Ridgewood Fire Department. J.H. Blauvelt ran a successful feed and grain business. Harvey Blauvelt sat on the board of the Paramus Valley Photographic Association along with local postcard publisher E.W. Cobb. (Courtesy of the Ridgewood Historical Society.)

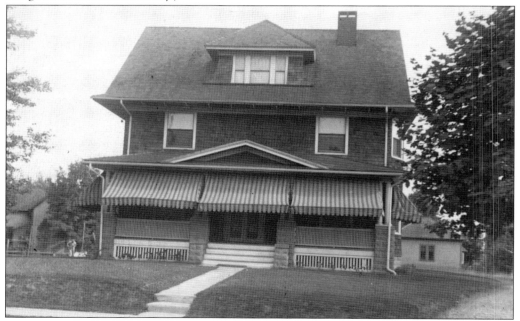

Although several of the Ackerman homes are listed in the National Register of Historic Places, this is not one of them. This home, on the corner of Godwin Avenue and the former Garfield Place, was a rather contemporary two-story brick home. The striped canopies harken back to the kitschy era of the 1950s. (Courtesy of the Ridgewood Historical Society.)

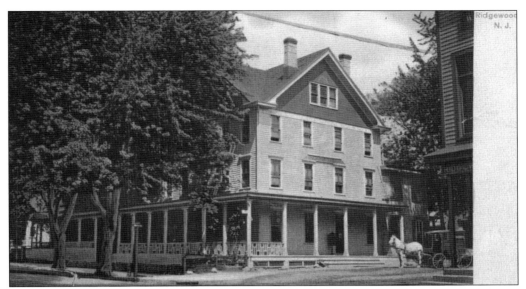

This house, on the northwest corner of Ridgewood and Maple Avenues, was the former home of Abraham and Annie Terhune. The house was built in 1870 and purchased by their son (and vaudeville magician) Harry. In short order, the home adopted his stage name, the Rouclere House, and became a hotel with a famous clientele, including Harry Houdini. The property is now a part of the Ridgewood retail core. (Courtesy of the Ridgewood Historical Society.)

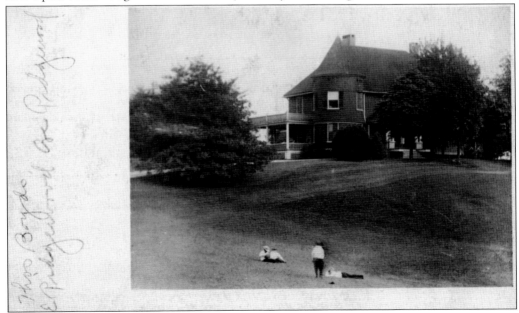

This idyllic spring view shows children playing along a grassy knoll on the property of Thomas Boyd, once on East Ridgewood Avenue. The Boyd family is just as famous for their sacrifice to the country as they were for their glorious Victorian home, which no longer stands. Thomas Milton Boyd died in combat action during World War I. He perished on October 2, 1918, and is remembered on the Ridgewood Veterans Memorial. (Courtesy of the Ridgewood Historical Society.)

The residential scene on this 1908 Ridgewood postcard shows a home sheltered behind several trees. Ridgewood hosts several varieties of tree species, including sycamores, cherries, lindens, wisterias, weeping willows, red cedars, sweet gums, magnolias, aspens, mittens, birches, pin oaks, locusts, and walnuts, among others. (Courtesy of the Ridgewood Historical Society.)

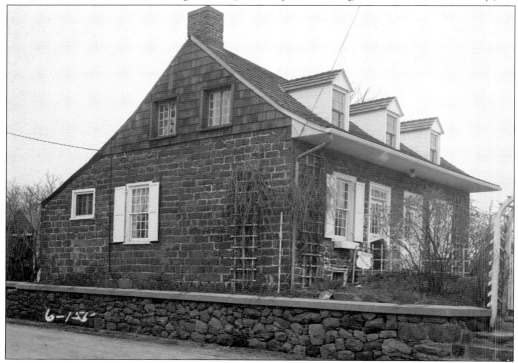

David Ackerman settled in the Ridgewood area in 1732. This house, at 415 East Saddle River Road, was more than likely built by his son Garret between 1750 and 1760, making it possibly the oldest standing house in the Ridgewood area. Built in the Dutch Colonial style, the home later had a kitchen and other living spaces added on. The house still has its original floorboards, mantel, and beams. The Ackerman House was added to the National Register of Historic Places on January 10, 1983. (Courtesy of the Library of Congress.)

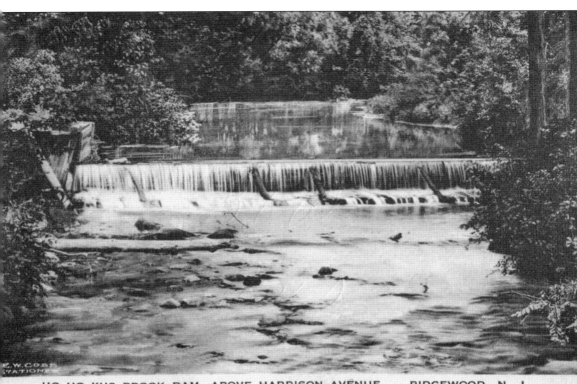

HO-HO-KUS BROOK DAM, ABOVE HARRISON AVENUE. RIDGEWOOD, N. J.

This pre-1915 postcard shows the dam on Harrison Avenue, just north of what is now Ridgewood on the Ho-Ho-Kus Brook. Given the rise of gristmills and paper mills in the area during the 19th century, dams such as this were not uncommon. Although the dam no longer exists, Harrison Avenue still does as part of the communities of Waldwick and Wyckoff. (Courtesy of the Ridgewood Historical Society.)

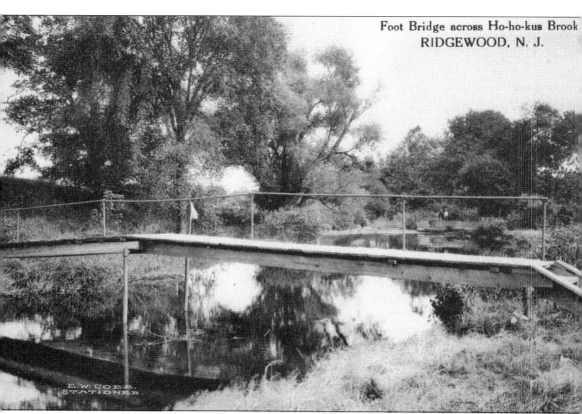

Foot Bridge across Ho-ho-kus Brook
RIDGEWOOD, N. J.

Long before the automobile became standard, foot traffic was just as vital to the travel and commerce of an area as the train or the wagon. Published in 1908, this postcard shows one of what were many footbridges to cross the Ho-Ho-Kus Brook at various points. Printed by famed local stationer E.W. Cobb, this gives an insight to how people crossed from one side of the waterway to the other, both to move livestock and greet one another. (Courtesy of the Ridgewood Historical Society.)

Two

HOME OF THE FAITHFUL
HOUSES OF WORSHIP

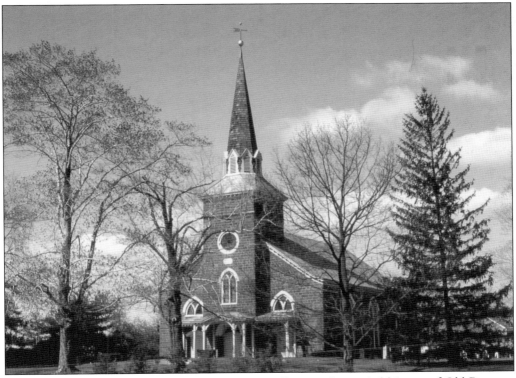

This modern image gives ample opportunity to reflect on the storied history of Old Paramus Church. The current building was put in place of the old one in 1800, replacing a building that had hosted dignitaries such as Alexander Hamilton, the Marquis de Lafayette, Anthony Wayne, Richard Henry Lee, and Aaron Burr, who famously shot Hamilton in a duel. The mission was further remodeled in 1873, after the Civil War. (Author's collection.)

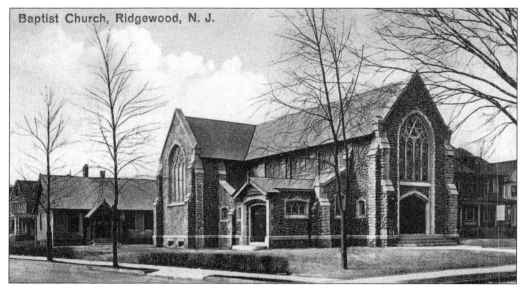

Founded in 1891, the Emmanuel Baptist Church of Ridgewood was, at its conception, a small parish of 30 souls who came together to form a congregation that today prepares to celebrate its 126th year. The naming of the church was particularly exciting; in a vote, Emmanuel won with nine votes, with eight for Calvary and seven for First Baptist. This 1905 card shows the church a scant 13 years after its construction and is labeled "Baptist Church, Ridgewood N.J." (Author's collection.)

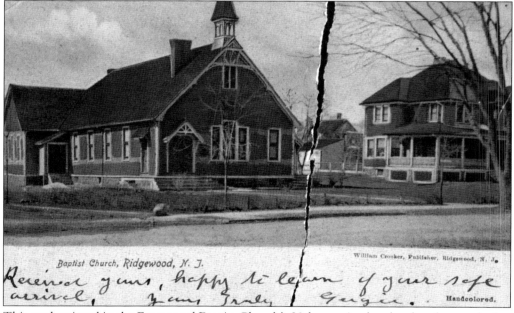

Baptist Church, Ridgewood, N. J.

William Crooker, Publisher, Ridgewood, N. J.

Handcolored.

This card, printed in the Emmanuel Baptist Church's 20th year, is a hand-colored example that was oddly not mailed until 1918. At the time of the card's printing, the church had undergone massive upgrades that were fully funded and paid for by congregation members. Mailed to Ada Pilgrim of Sugar Loaf, New York, the message on this card reads, "Hello Ada. Hope that you are well and happy. Ida." (Courtesy of the Ridgewood Historical Society.)

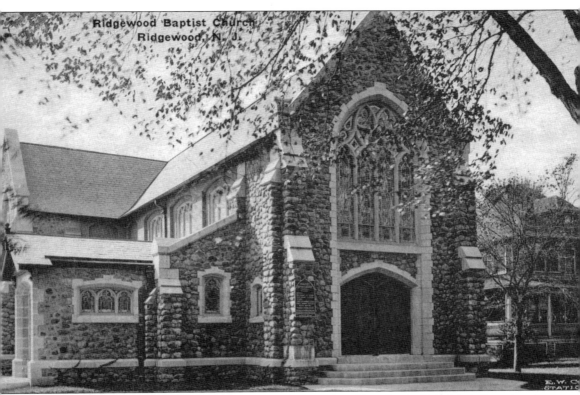

A handwritten note on the back of this card, which was printed in color in 1941, labels Emmanuel as "First Baptist Church, Ridgewood, New Jersey." By the time of its printing, the church had gone from a small congregation of 30 souls to one of the more influential Baptist congregations in the nation. So powerful, in fact, was Emmanuel's progressive influence that when the American Baptist headquarters were in nearby New York City, its board was often littered with Emmanuel members. (Courtesy of the Ridgewood Historical Society.)

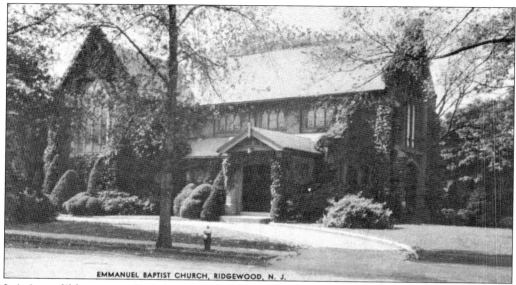

EMMANUEL BAPTIST CHURCH, RIDGEWOOD, N. J.

It is incredibly rare to find the photographic subject for a linen-printed postcard, but that appears to be the case with this photographic version of the linen postcard pictured earlier of the Emmanuel Baptist Church in Ridgewood. Emmanuel continues its ministry of outreach today, with mission trips to Haiti and resettlement of refugee families from Southeast Asia. It also leads a program to revitalize inner-city Baptist congregations. (Courtesy of the Ridgewood Historical Society.)

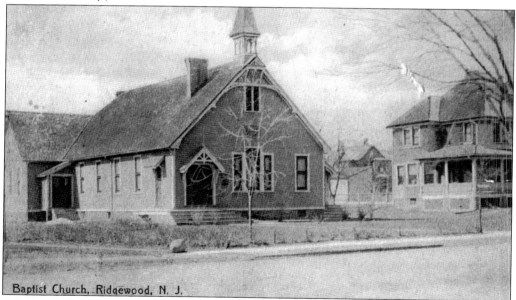

Baptist Church, Ridgewood, N. J.

P.G. Zabriskie was responsible for the construction of the Emmanuel Baptist Church, which was dedicated on November 13, 1892. The church cost $3,028 to build, or a little over $82,000 in 2017. Located at the corner of Hope Street and East Ridgewood Avenue, a small annex would be added in 1897 before what the 1916 publication *Ridgewood, Bergen County, New Jersey, Past and Present* calls a Decorated English Gothic–style chapel was erected to replace the original in 1912. (Courtesy of the Ridgewood Historical Society.)

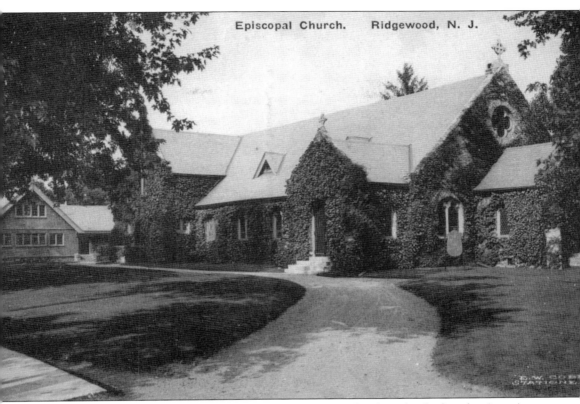

Episcopal Church. Ridgewood, N. J.

Although the Episcopal Church spun off from the Church of England after the American Revolution, it would be the Civil War era before Ridgewood had an Episcopal congregation of its own. This congregation was founded in 1864 by Samuel Dayton, along with several of his relatives. This interior view shows both the main altar and the beautiful stained glass, with the pews adorned with poinsettias for Christmas celebration. This ivy-covered stone structure was built in 1900 and is not the original edifice for Christ Episcopal Church. The first structure was a wooden one erected on the western side of Van Dien Avenue. That building was relocated across an empty field to the present site in 1873. In 1895, it was decided that the old wooden building was inadequate to meet the demands of a growing congregation, and thus this building was constructed. (Author's collection.)

43

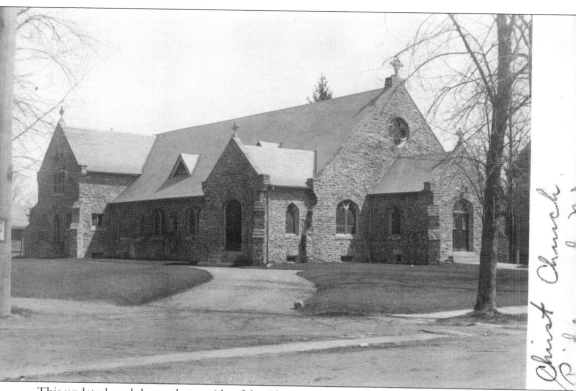

This undated card shows the outside of the Christ Episcopal Church. The caption reads, "Christ Church. Ridgewood, N.J." The church's construction in 1865 was shrouded in tragedy. William Ranlett, a homebuilder of local renown, died before his creation could be completed. Sadly, Ranlett died from a fall from his horse on his way home from retrieving the remains of his son, who had perished in 1865 during the Civil War. (Courtesy of the Ridgewood Historical Society.)

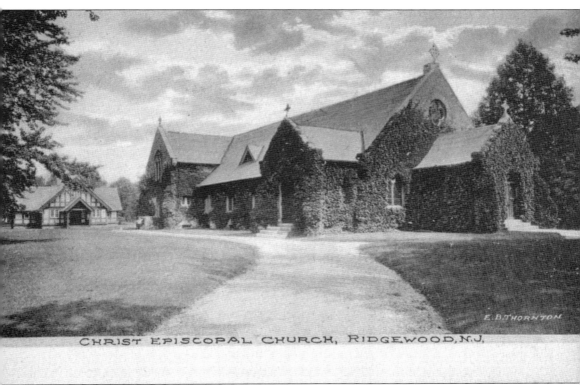

CHRIST EPISCOPAL CHURCH, RIDGEWOOD, N.J.

Mailed from Ridgewood at 12:30 p.m. on October 1, sometime after 1901 but before 1907, this card shows a straightforward view of the exterior of Christ Episcopal Church. Addressed to a Lyman M. Piatt of Troy, Pennsylvania, the message on the back of the card reads, "I like it real well. Write to me. 147 Godwin Avenue. Pansie." (Courtesy of the Ridgewood Historical Society.)

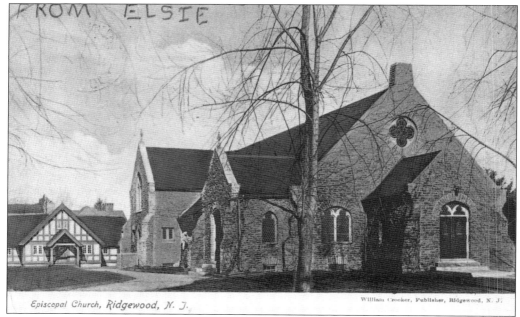

Episcopal Church, Ridgewood, N. J.

William Crooker, Publisher, Ridgewood, N. J.

Christ Episcopal Church still has a staff of two salaried clergies and six laypeople. This card, produced between 1915 and 1930, shows a pristine watercolor view of the church, which, much like in English tradition, is covered in green ivy. Published by local Ridgewood publisher William Crooker, the front of this card reads, "Episcopal Church, Ridgewood, N.J." and a note in the upper left corner reads, in childlike script, "From Elsie." (Courtesy of the Ridgewood Historical Society.)

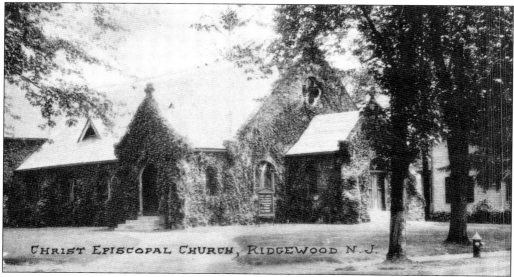

CHRIST EPISCOPAL CHURCH, RIDGEWOOD N. J.

Christ Episcopal Church is a community that seeks to celebrate the lives of its parishioners. Never was this more apparent than on June 14, 2015, when the church hosted a celebration for the 100th birthday of its oldest living member, Marion Kortjohn. With a friend's dog, Tucker, in her lap, Kortjohn was greeted with a champagne toast and a proclamation from Ridgewood mayor Paul Aronsohn. (Courtesy of the Ridgewood Historical Society.)

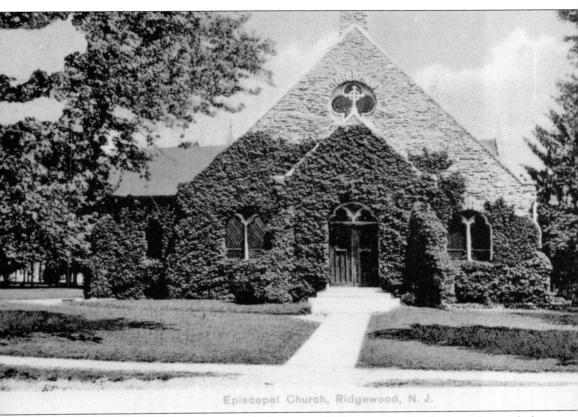

Episcopal Church, Ridgewood, N. J.

This front view of Christ Episcopal Church shows the Celtic cross that has become the symbol for the faith, as well as the ornate stained-glass windows that are surrounded by ivy, as in the old-world tradition. In an attempt at modernity, the church has expanded to social media and can be found on both Facebook and LinkedIn. (Courtesy of the Ridgewood Historical Society.)

Members of an offshoot of the old Dutch Reformed congregation that was one of the earliest in the Ridgewood area, the congregation of the First Presbyterian Church can trace its roots back to the True Reformed Church, which it spun off from in 1899 after a decision to abandon more Puritanical church values. The congregation struggled until the building pictured, the church's current home, was built at its present location at Van Dien and Ridgewood Avenues in 1927. (Author's collection.)

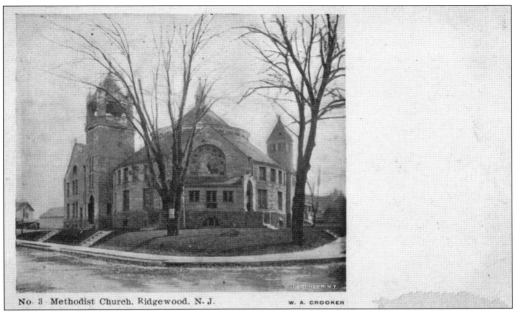

No. 3 Methodist Church, Ridgewood, N. J. W. A. CROOKER

This 1903 postcard, one of the oldest cataloged here, shows the Ridgewood Methodist Episcopal Church. This card, published by famed printer E.B. Thornton, features the rotunda of the building behind a dirt road. As the back of postcards at the time were only used for addresses, there is much space left on the front so senders could write out whatever message they intended for the recipient. This structure was abandoned in 1964 when the congregation moved to a larger building. (Author's collection.)

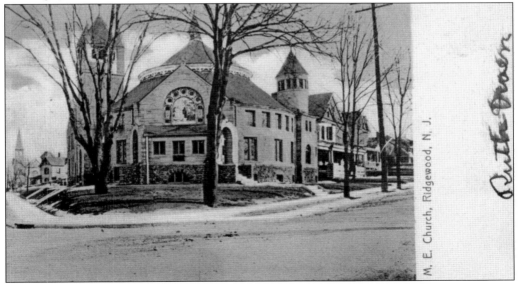

Taken in 1906, the image on this card (colored by hand in red, blue, and green) shows the progression of the Ridgewood Methodist Episcopal Church. Although the road remains dirt, power lines are visible. The church was organized in 1896 under the guidance of Rev. Frank Chadwick. The first services were held in an old schoolhouse on Prospect Street. The card is signed by Ruth Draen. (Courtesy of the Ridgewood Historical Society.)

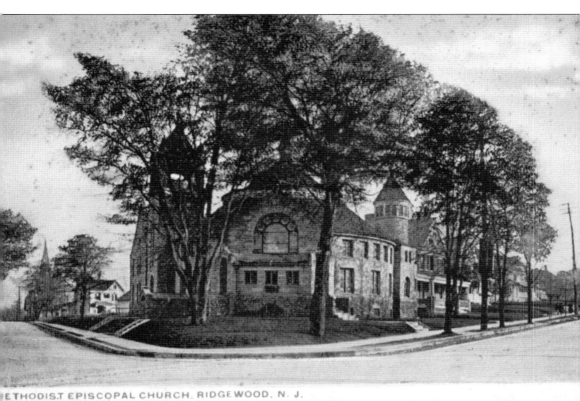

ETHODIST EPISCOPAL CHURCH, RIDGEWOOD, N. J.

Painted in 1910, the front of this card shows the Ridgewood Methodist Episcopal Church with a lighter color. A small outbuilding can be seen on the left, and the road in front of the building remains unpaved. The bell tower of the building and its many stained-glass windows are visible. The card is captioned, "Methodist Episcopal Church, Ridgewood, N.J." (Author's collection.)

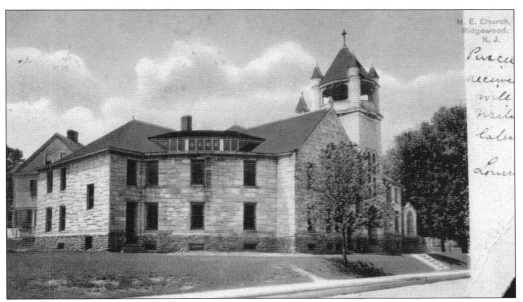

Painted in its full-color glory, the Ridgewood Methodist Episcopal Church is shown in this 1920s postal quite differently than other inceptions. One must wonder how much artistic license was taken; after all, this is a linen postcard that displays the church in a tan color with a red roof. A flagpole stands out front, while the roads remain dirt. (Courtesy of the Ridgewood Historical Society.)

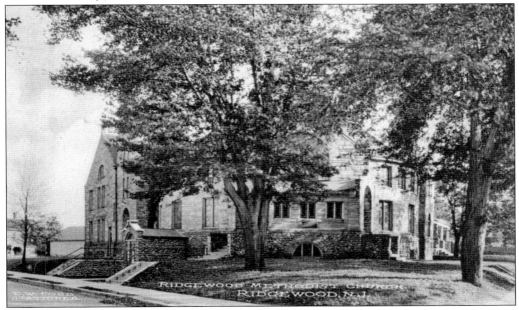

Postmarked May 2, 1930, this black-and-white card, published by E.W. Cobb, shows a rather shady view of the Ridgewood Methodist Episcopal Church. Addressed to Bonnie E. Gould of Seneca Falls, New York, the message on the card reads, "Dear sister: This is a picture of the church where we attended dinner service yesterday. Please preserve this card as a memorial of this universal theme. Love, E & J." (Courtesy of the Ridgewood Historical Society.)

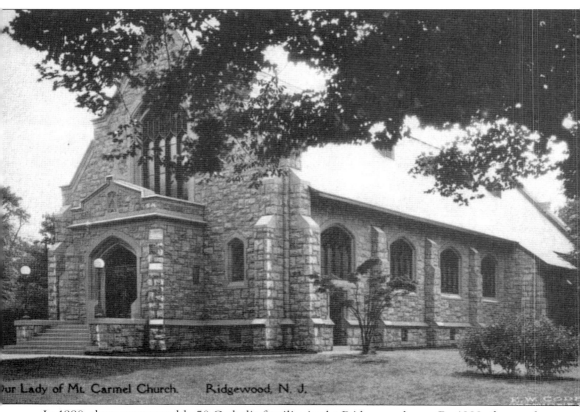

Our Lady of Mt. Carmel Church. Ridgewood, N. J.

In 1880, there were roughly 50 Catholic families in the Ridgewood area. By 1888, the number had grown enough to justify the establishment of a parish in the town. Fr. Michael Nevins was appointed in 1890 to establish Our Lady of Mount Carmel. The original church and rectory came about as an 1890 donation of a home on Union Street by Joseph and Mary Carrigan. From there, Our Lady of Mount Carmel Church would continue to grow. (Author's collection.)

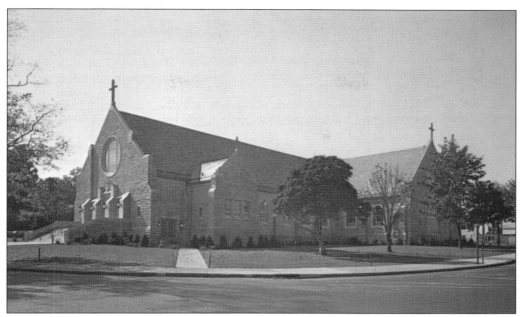

This 1970s view shows the entirety of Our Lady of Mount Carmel Catholic Church. This building was conceived in 1959, when the parish razed the initial church on Passaic Street. The cornerstone was laid in 1960. The first property, on Passaic Street, was planned in 1912 and constructed in 1914. The church celebrated its 100th anniversary here in 1989. (Author's collection.)

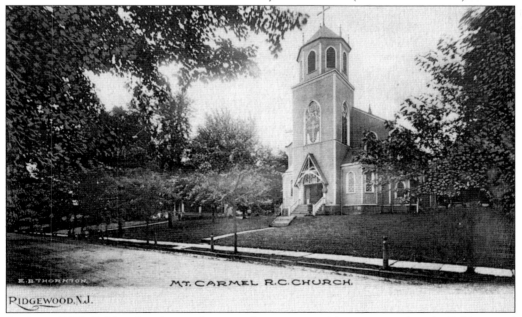

Stationer E.W. Cobb printed several postcards on many subjects concerning the Ridgewood area, and Our Lady of Mount Carmel is no exception. So popular was this card, featuring a sideward front view of the church, that the Ridgewood Historical Society has three unused copies of it in its archives. The front of the card reads, "Mt. Carmel R.C. Church. Ridgewood, N.J." (Courtesy of the Ridgewood Historical Society.)

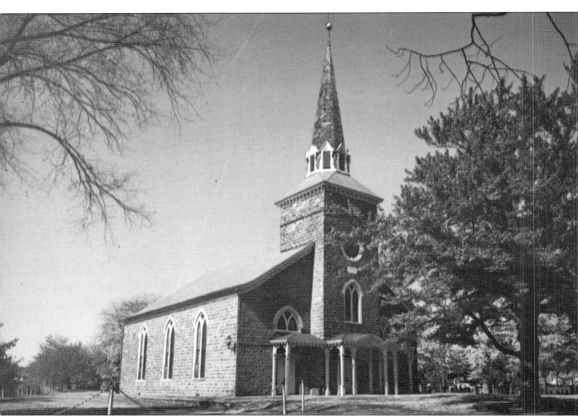

Just as important as the Old Paramus Church itself is the graveyard adjacent to it. The earliest headstones date back to 1735, and the last to be buried here was in 1852. The roughest gravestones are those of the earliest settlers in the area. Many soldiers from both sides of the Revolutionary War are buried here, including victims of a British raid in March 1780 and Capt. John Hooper, an officer from Bergen County who served in militia forces during the conflict. (Courtesy of the Ridgewood Historical Society.)

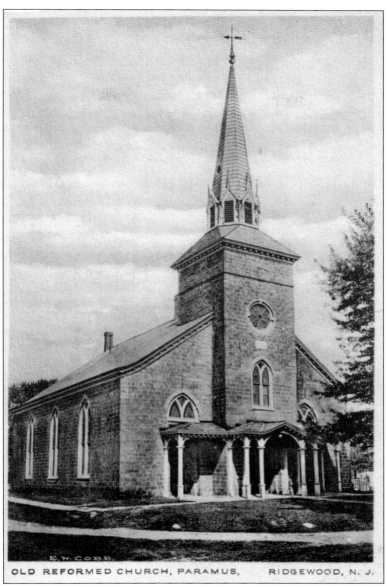

OLD REFORMED CHURCH, PARAMUS, RIDGEWOOD, N. J.

Old Paramus Reformed Church serves as the cornerstone of the Paramus Reformed Church Historical District. The area was listed in the National Register of Historic Places on February 25, 1975. Its boundaries are Franklin Turnpike, New Jersey Route 17, the Saddle River, the cemetery on the grounds, and Glen Avenue, all of which, despite the building's name, lie within the boundaries of Ridgewood. The history of the Ridgewood Historical Society and the Old Paramus Reformed Church go hand in hand. The Schoolhouse Museum, which currently houses the historical society, was once the schoolhouse for the Old Paramus Reformed Church. The building was constructed in 1872 and was used as a one-room schoolhouse until 1905. It has been replaced with a more modern educational center, which is used to nurture and educate about the Christian lifestyle. This is just a small part of the church's 292-year history. The front of this card, published by stationer E.W. Cobb, reads, "Old Reformed Church, Paramus. Ridgewood, N.J." (Courtesy of the Ridgewood Historical Society.)

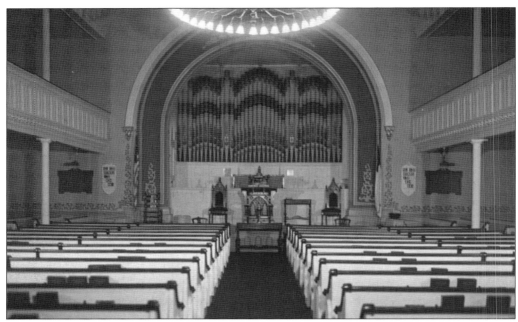

The interior of the Colonial church is striking. Shown are both the rows of pews and the balconies that allow more parishioners to crowd in for services. The back of this card, published by David E. Repetto, reads, "Old Paramus Reformed Church, Ridgewood N.J., organized in 1725 is one of the earliest churches in the area. The interior is a striking modern restoration of late colonial. Built in 1800 the historic old church was restored in 1950." (Courtesy of the Ridgewood Historical Society.)

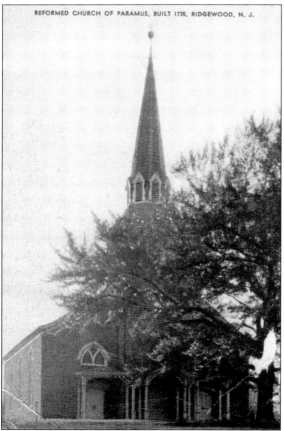

REFORMED CHURCH OF PARAMUS, BUILT 1735, RIDGEWOOD, N. J.

The Old Paramus Reformed Church has a history older even than the nation. Formed in 1725, this mission served as George Washington's headquarters an astonishing 10 times during the Revolutionary War. It was also the site of Washington's court-martial of Gen. Charles Lee, who is said to have disobeyed orders at the Battle of Monmouth in 1778.(Courtesy of the Ridgewood Historical Society.)

The history of the denomination that makes up the Old Paramus Reformed Church dates back 150 years before the founding of America. The Reformed denomination, part of the Protestant Reformation, was established in 1628 in present-day New York City, at the time a Dutch colony known as New Amsterdam. An evangelical church, its primary focus is ministry and conversion to the word of Christ. The front of this card, which features the old graveyard, reads "Old Paramus Church." (Courtesy of the Ridgewood Historical Society.)

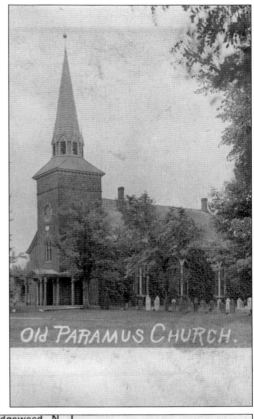

Produced between 1915 and 1930, this card shows a side-front view of the Westside Presbyterian Church, brought to life in watercolor. Mailed at 6:30 p.m. on September 4, 1940, this card was sent to Audrey Perkins, at 72 Crescent Street in Rutland, Vermont. The message to Audrey reads "How do you like Lincoln school? I took a nice trip today. See you Sunday. Phyllis." The front of the card reads "West Side Presbyterian Church, Ridgewood, N.J." (Author's collection.)

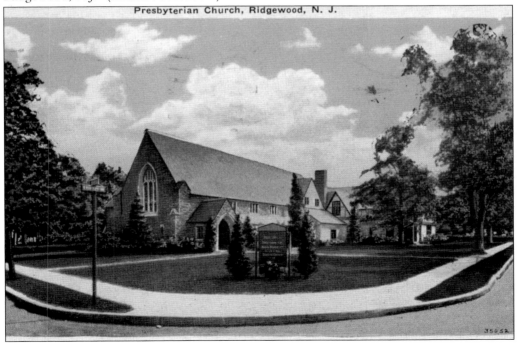

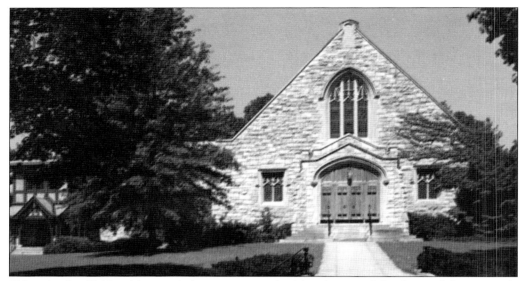

Taken in the 1960s, this postal shows a warm, inviting image of the front of the Westside Presbyterian Church. The congregation renovated the mission in 1999, only to have a fire completely wipe out the $1.8 million upgrade in 2002. Undeterred, the faithful contracted Newman Architects to design a new structure, making sure to use some of the same block and walls that had been salvaged from the original building. The new church stands as a testament to the dedication of the congregation. (Author's collection.)

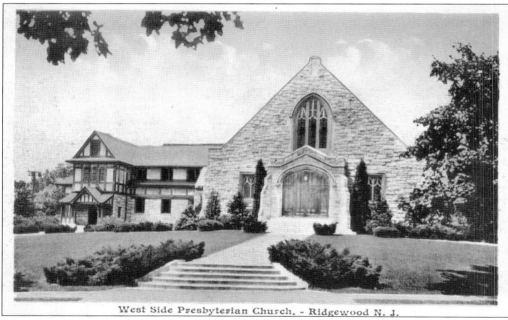

West Side Presbyterian Church. - Ridgewood N. J.

Printed between 1915 and 1930, this card shows a front view of the Westside Presbyterian Church in Ridgewood. Always active in the community, Westside currently hosts jazz concerts in conjunction with the Ridgewood Arts Foundation. The church also hosts a yearly art gallery, with proceeds going to fulfill the church's mission. There are always reasons for the faithful to visit 6 South Monroe Street. (Author's collection.)

The front of this card, with a message in ink in the lower section (as was customary for all postcards before 1907, as federal mandate stated that only the address of the recipient could go on the back) gives a detailed history of the First Reformed Church. It reads, "First Reformed Church established 1875. Building completed 1877. Extensive additions made in 1890–1900 and 1914. First minister Rev. J.A. Von Ness. Church burned." (Courtesy of the Ridgewood Historical Society.)

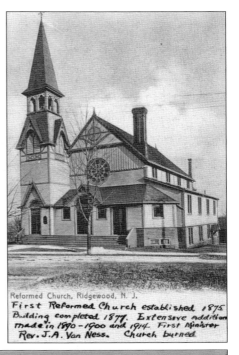

Reformed Church, Ridgewood, N. J.
First Reformed Church established 1875 Building completed 1877. Extensive addition made in 1890-1900 and 1914. First Minister Rev. J.A. Van Ness. Church burned

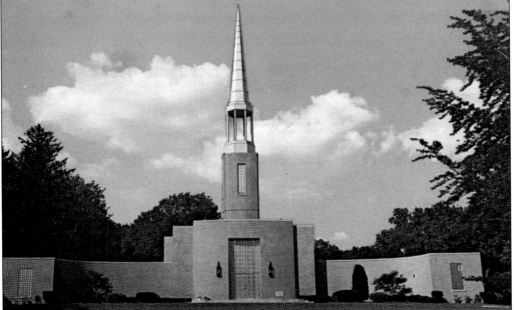

This modern view shows the First Church of Christ, Scientist (known home to the World Mission Society Church of God) in Ridgewood. Although praised by Bergen County officials for its prompt charitable responses during emergencies, the World Mission Society Church of God is not without its critics. The church has been accused in the past of promoting a belief that the world would end in 2012, a belief that, given the 2017 composition of this book, fell short. (Courtesy of the Ridgewood Historical Society.)

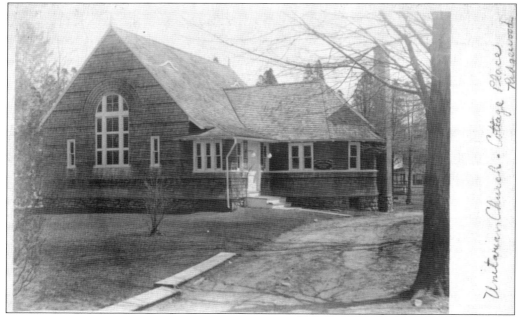

Unitarian Church - Cottage Place, Ridgewood

Not all churches are constructed to host thousands of the faithful. Shown here is the headquarters of the Unitarian Universalist congregation of Ridgewood, on Cottage Place. Addressed to Lauren Olson at 759 West 138th Street in New York City, the message on this card appears to be in German and is signed by "Annie." The congregation, which seeks to be inclusive and antiracist, still meets for services at 113 Cottage Place. (Courtesy of the Ridgewood Historical Society.)

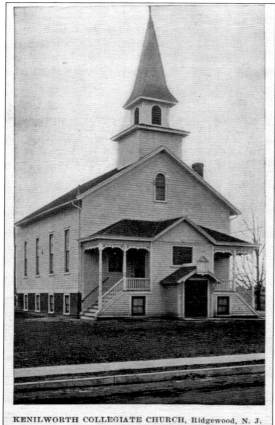

KENILWORTH COLLEGIATE CHURCH, Ridgewood, N. J.

The former Kenilworth Collegiate Church can trace its roots back to 1823, when it was established in Ridgewood. The building shown here was erected in 1858, and the group organized originally as the True Reformed Dutch Church of Paramus. The group reorganized again in 1870 as the Kenilworth Collegiate Church and left the Reformed denomination for the Presbyterian in 1898. The Reverend Dr. Lansing was the first pastor to serve the church. The change in denominations was led by Rev. Harvey Iseman. The front of the card reads, "Kenilworth Collegiate Church, Ridgewood, N.J." (Courtesy of the Ridgewood Historical Society.)

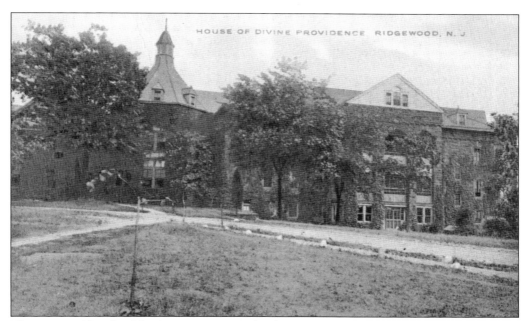

The current Church of the Annunciation used to be in Ridgewood (after a shift in city borders, it is now in Paramus) and was known as the House of Divine Providence. However, the building pictured here did not start life as a church. Rather, it was established in 1891 by Mother Xavier Mehegan as a home for patients with incurable illnesses. A chapel was added in 1908 that serves as the congregation's primary place of worship in the present day. The front of the card reads, "House of Divine Providence, Ridgewood, N.J." (Courtesy of the Ridgewood Historical Society.)

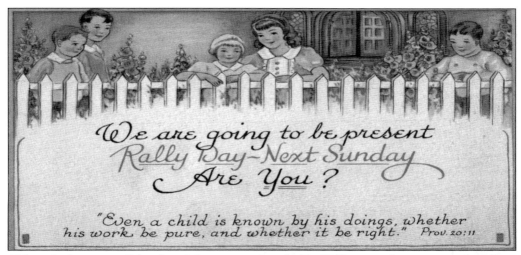

Although the name of the church is not mentioned, this 1948 postcard was postmarked from Ridgewood on September 29 at 7:30 p.m. An invitation to a Rally Day Celebration, this card is sent from a Miss Bowers to Edith Brisiman, imploring her to also come to Sunday school on October 3, 1948, at 9:45 a.m. The young children on the front of the card are featured above a quote from Proverbs 20:11. (Author's collection.)

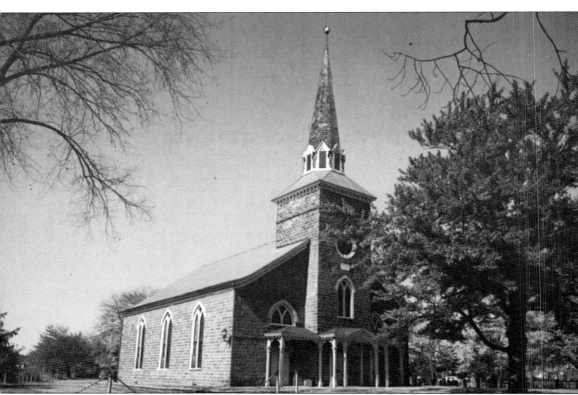

Old Paramus Reformed Church is located at 660 East Glen Avenue, within walking distance of the Ridgewood Historical Society Museum. Twenty-seven samples of wartime correspondence from Gen. George Washington are known to have originated at Old Paramus. The building is a Neo-Gothic icon made from local stone. Both sides of the Revolutionary War used the grounds during the war; the current edifice was constructed in 1800. (Courtesy of the Ridgewood Historical Society.)

Three

BUSINESS WITH NEIGHBORS
LOCAL COMMERCE

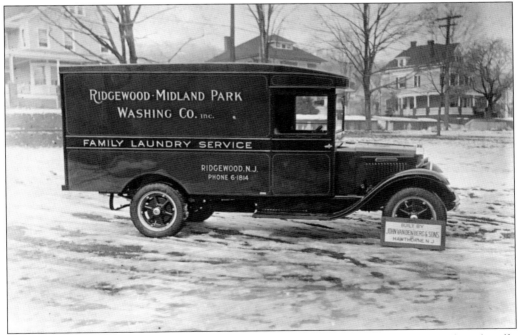

Before the rise of at-home washers and dryers, it was common for a laundry truck to handle the clothing and laundering needs of families in the Northeast. This is one such truck. The side proudly advertises "Ridgewood-Midland Park Washing Company. Family Laundry Service. Ridgewood, N.J. Phone 6-1814." There are ulterior motives at work here, as a sign by the front tire proclaims, "Built by John Vandenberg & Sons, Hawthorne, N.J." (Author's collection.)

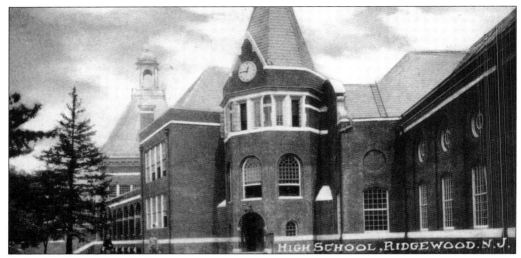

Shown here in 1905, Ridgewood High School was founded in 1892 when principal B.C. Wooster organized the ninth-grade students into the first freshman class. Sophomores would not come into existence until the next year. This Beech Street building was in use by the high school until, due to rapid growth, it was vacated in favor of facilities that, despite a voter defeat, began construction when the state appropriated $225,000 (later raised to $285,000) for the building of a new school. This card was addressed to a Reverend James in Jericho, New York. (Author's collection.)

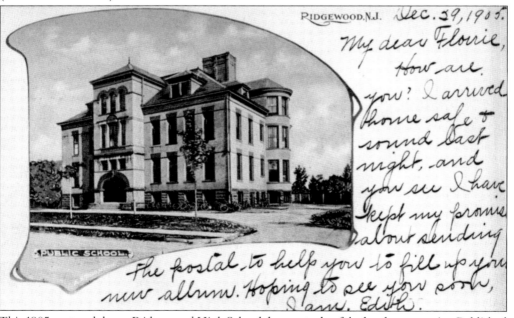

This 1905 postcard shows Ridgewood High School, long a staple of the local community. Published before the rise of split-back cards, this image features both a border and text that is relegated to the front of the card. The text reads, "Dec. 29, 1905. My dear Florrie, How are you? I arrived home safe & sound last night, and you see I have kept my promise about sending the postal to help you to fill up your new album. Hoping to see you soon, I am, Edith." (Author's collection.)

This mailing advertisement, sent in 1947, targeted farmers in Ridgewood and the Greater Paramus Valley area. While there was water available from the Saddle River, the Ho-Ho-Kus Brook, and several nearby ponds and streams, transporting it to the fields was another question altogether. Marlow Pumps helped in that endeavor. The company provided more than just water irrigation pumps. It also provided pumps for dairy farming and fire control. (Author's collection.)

Alfred S. Marlow Jr. was the biggest name in pump manufacturing in the Ridgewood area. The holder of multiple pump patents, Marlow served as the first secretary-treasurer of the Sprinkler Irrigation Association upon its formation in 1949. This trade group was dedicated to both shared marketing and technological investments in the pump industry. Marlow Pumps lives on today as a part of the multinational pump manufacturer Watson–Marlow Fluid Technology Group. (Author's collection.)

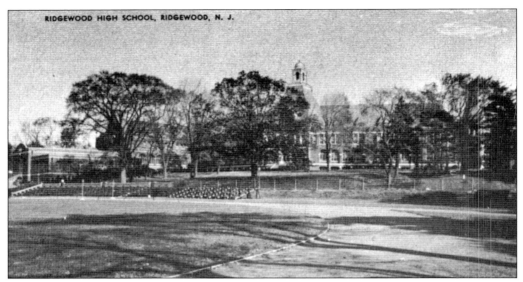

RIDGEWOOD HIGH SCHOOL, RIDGEWOOD, N. J.

This view of the football field at Ridgewood High school is fitting, seeing as the team is today one of the more celebrated teams in the state of New Jersey. The Maroons finished the 2016 season by going undefeated and winning the New Jersey North 1, Group 5 title with a 14–13 victory over Passaic Tech at the Meadowlands in East Rutherford, home of the NFL's New York Giants and New York Jets. It was the first state sectional championship for the Maroons since 2004, and their fifth overall. (Courtesy of the Ridgewood Historical Society.)

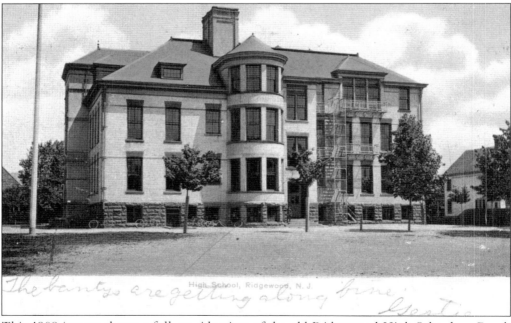

High School, Ridgewood, N. J.

This 1909 images shows a full-on side view of the old Ridgewood High School on Beech Street. Visible against the building is a fire escape, common for multistoried buildings at the turn of the century. The writing on the front of this card reads, "The bantys are getting along fine. Gertie." The text on the front of the card reads, "High School, Ridgewood, N.J." (Author's collection.)

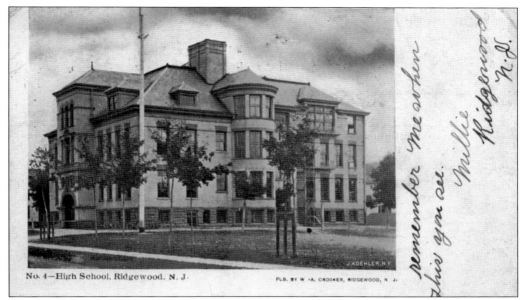

No. 4—High School. Ridgewood. N. J. PUB. BY W ·A. CROOKER, RIDGEWOOD, N J.

Football is not the only sport played by the bright pupils at Ridgewood High School. On the boys' side, the school fields teams in alpine skiing, cross country, soccer, tennis, basketball, bowling, ice hockey, indoor track, swimming, wrestling, baseball, golf, lacrosse, and outdoor track. On the girls' side, there are teams in alpine skiing, cross country, gymnastics, soccer, tennis, volleyball, basketball, bowling, indoor track, swimming, golf, lacrosse, softball, and outdoor track. (Courtesy of the Ridgewood Historical Society.)

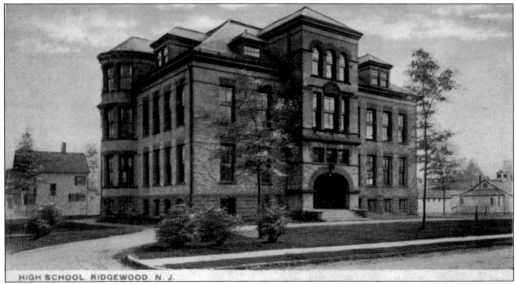

HIGH SCHOOL. RIDGEWOOD. N. J.

Traditional team sports are not the only areas in which the Ridgewood High School Maroons excel. The school fields a full marching band that has its own share of success. In 2016, marching band director John Luckenbill won the Positive Coaching Alliance's Double Goal Coach Award, given for reaching the organization's goal of "teaching life lessons through sports." Ridgewood High School also fields an acclaimed cheerleading squad, which won its classification's national championship in 2016. (Courtesy of the Ridgewood Historical Society.)

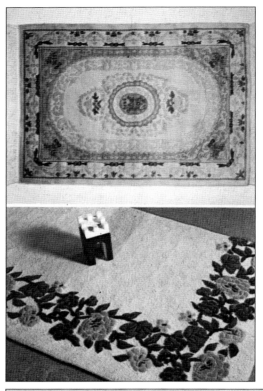

This 1960s postcard shows a rug template sampler for Edward Molina Designs. Molina sold his wares at the Merchandise Mart in Chicago and in the Textile Building in Lower Manhattan. The Merchandise Mart, formerly owned by the Kennedy family, was at one point the largest building in the world. The Textile Building was constructed in 1920 and has been the hub for home textiles in New York since. Molina was born in San Juan, Puerto Rico, graduated from Dartmouth, and served in the US Navy during World War II. He died in 2014. (Author's collection.)

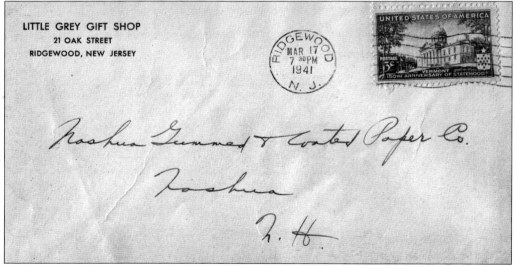

This mailer was sent on March 17, 1941, from the Little Grey Gift Shop, formerly on Oak Street in the downtown core. The gift shop closed in 1957, but in its place stands Levato Eyewear, which moved in in 1958. The current owner is Don Axelband, who graduated with a degree in optometry from Brooklyn College in 1978. When the previous owners sought to sell the business, Don snapped it up, and in 2000, he went into business for himself after having worked for two years at the State University of New York College of Optometry in Manhattan. (Author's collection.)

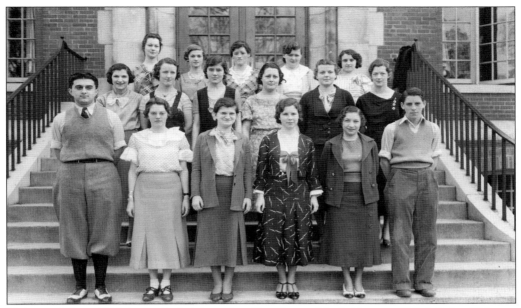

This postal from 1933 shows the bright and smiling faces of the Ridgewood High School Library Club. On the back, only the seniors are identified: Eileen Costa, Anne McCambridge, Anna Goeller, Sarah Goldberg, Augusta Krumm, Laura Morgan, Virginia Redding, Lucille Russo, Dorothy Young, and Vivian Gandolph. Who's who is not noted. The group is shown on the steps to the main entrance of the school. (Author's collection.)

This 1943 linen postcard shows part of the new facilities that Ridgewood High School moved into on May 7, 1919. The move was delayed slightly by World War I. By 1929, rapid growth and reorganization saw the freshmen move to two different middle schools, with Ridgewood High School retaining the sophomore through senior classes. By this date, the number of faculty had doubled, and the number of students had expanded greatly. The writing on the back of this card reads, "High school where Tommy attends. Sue, sent Dec 27 1943." (Author's collection.)

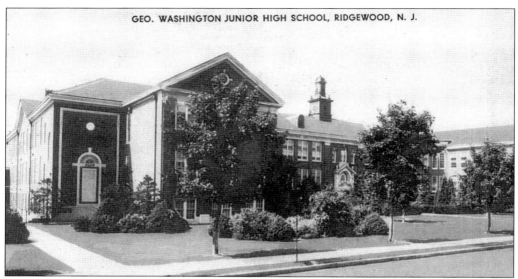

Constructed in the 1920s, George Washington Junior High was one of the two schools (along with Benjamin Franklin Junior High) that absorbed the ninth-grade class when the freshmen were moved back into middle school in 1929. The classic brick building was given a recent renovation under Reading Rock Solutions that took 18 months. This renovation cleaned and repaired the brick and expanded the gym to be one of best gyms in the state of New Jersey. (Author's collection.)

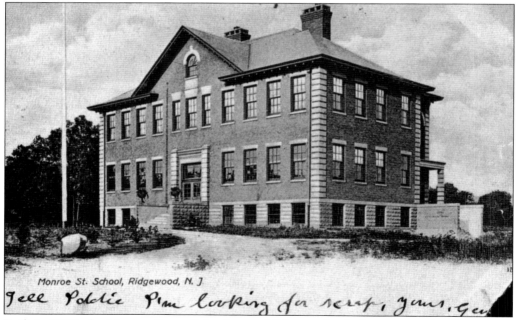

Monroe St. School, Ridgewood, N. J

Built in 1905, the Monroe Street School started life as a simple four-room schoolhouse. An ever-growing population of schoolchildren, however, called for additions in 1911. The building stood until 1926, when it and the Willard School were both mysteriously consumed by fire. The school was rebuilt with much fanfare in 1927, but it was reopened as George Washington Junior High School. (Courtesy of the Ridgewood Historical Society.)

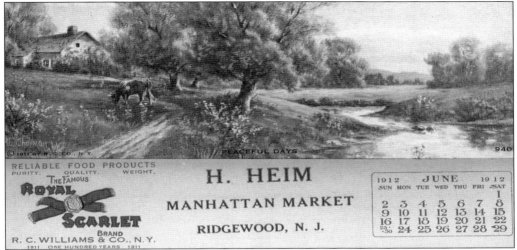

Henry Heim's Manhattan Market was a retailer of groceries and other fine foodstuffs in Ridgewood. Shown on this 1912 postcard is a calendar advertisement. Little is known about Heim himself; census records from 1910 list that he is a German immigrant boarding in Harriet Hopper's house in Ridgewood. He is not present in either the 1900 or 1920 census. Given the rise of anti-German sentiment surrounding World War I, it is fair to postulate that Heim's market suffered and he was forced to move on. (Author's collection.)

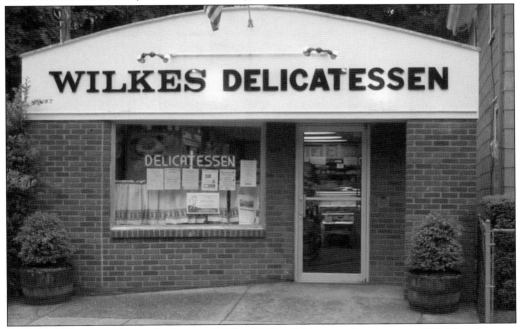

This undated image shows the front of Wilkes Deli, a Ridgewood mainstay at 283 Glen Avenue. Open from 6:30 a.m. to 7:00 p.m. seven days a week, the deli provides walk-in services and catering to groups starting at 10 people. It offers both hot and cold deli and buffet fare. Many a local can recount fond meals and conversations over the outstanding fare at Wilkes. The deli has been open for over 50 years and has been run by three generations of the Wilkes family. (Author's collection.)

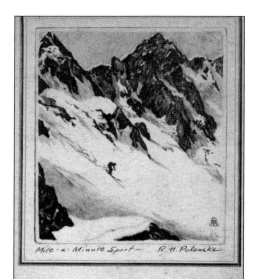

This oversized postcard is an advertisement for the Aleresky Brothers, an early landscaping company that operated in both Englewood and Ridgewood. This advertisement was printed by Brown & Bigelow of St. Paul, Minnesota. One unique aspect of this advertisement is the inclusion of Reinhold H. Palenske's drawing *Mile-a-Minute Sport*. Palenske was born in 1884 in Chicago and died in Woodstock, Illinois, in 1954. So renowned is his artwork that three of his pieces belong to the Smithsonian. (Author's collection.)

Mailed from the Ramapo Stamp Company in 1955, this correspondence was addressed to Rod Phinney, a lifelong Ridgewood resident. Phinney served his country as a bombardier in the 401st Bombardment Group during World War II. After the war, he took a job at Ridgewood Motors (at 555 North Maple Avenue, which now belongs to the Valley Hospital Group) for a time before opening the Ridgewood Train and Hobby Center, which he ran until his retirement. Phinney died in 2004 and is survived by his son, Rod, and Rod's wife, Anne (an author in her own right), who run Moose River Farm in Old Forge, New York. (Author's collection.)

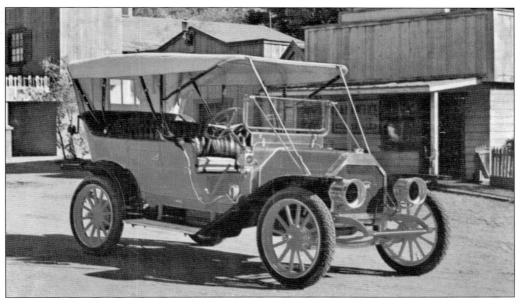

Craig Wood Ford no longer sells automobiles, but its marketing techniques still command attention. This postcard shows a 1911 Overland Roadster while talking up the many benefits of the service department at the dealership. Sent to H.H. Clark, Jr. in nearby Teaneck, the message implies that Clark's car could last just like the 1911 if he allows it to be serviced by Craig Wood Ford. (Author's collection.)

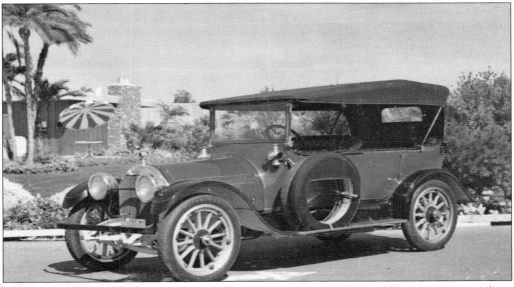

With a picture of a fire-engine-red 1915 Stevens-Duryea gracing the front, this postcard from Craig Wood Ford entices the viewer to come in for something besides maintenance work. The back of the card tells recipients that they save in two ways by having a 1,000-mile inspection done: operating costs and the purchase of a new car. Craig Wood Ford was located at 555 North Maple Avenue in Ridgewood. (Author's collection.)

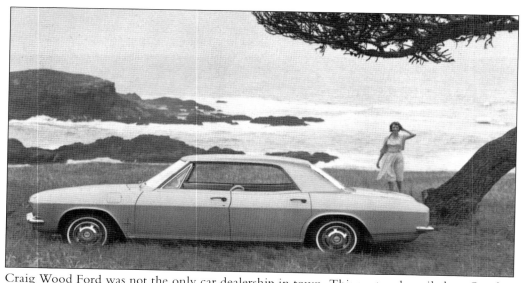

Craig Wood Ford was not the only car dealership in town. This postcard, mailed on October 2, 1964, shows the brand-new Chevrolet Corvair in seafoam green. The car boasted a 2.7-liter inline-six engine and came available with an automatic transmission. Unlike the sales department at Craig Wood Ford, Fred Becker, the Nadler Chevrolet salesman, preferred to handwrite his sales cards. The back of the card reads, "Bring this card see me I can Save you money on a new Chev. Fred Becker." It was addressed to J. Cassel at 277 North Murry Avenue in Ridgewood. (Author's collection.)

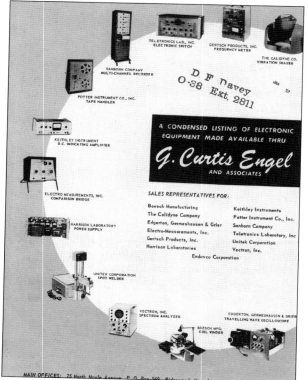

This oversized postcard was mailed as an advertisement for G. Curtis Engel and Associates, a company dealing in small electrical components, which represented, as a wholesaler, over a dozen manufacturers. The equipment offered was largely in the manufacturing sector, with machines from spot welders to "direct writing inkless recorders" available. This oversized article was mailed by salesman D.F. Davey, who is not tied to Ridgewood by census records. The building at 75 North Maple Avenue now houses several businesses, including Huntington National Bank, Haberman Dermatology Institute, and the COR Group. (Author's collection.)

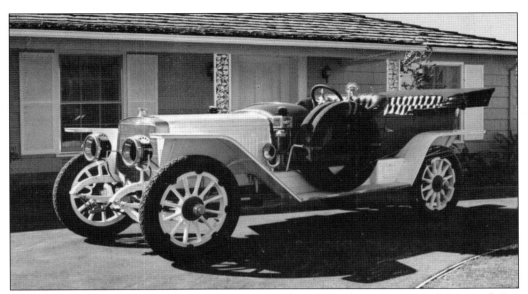

With a bright-white 1913 Lazier gracing its cover, this postcard encourages recipients to bring their vehicles to Station Motors for all their maintenance and repair needs. Station Motors still stands at 44 Franklin Avenue in Ridgewood (the gas station and repair facility behind the post office, next door to Wells Fargo Bank). This card was mailed to Carolyn King at 368 Westfield Avenue in Ridgewood on February 9, 1960. (Author's collection.)

This card shows the view when one enters the business district on East Ridgewood Avenue in Ridgewood. Aside from the 1970s-era automobiles, one can see at center the Ridgeowood Post Office, which shares its own bit of infamous lore in American history—the 1991 shootings by former postal clerk Joseph Harris. The back of this card, published by Pendor Natural Color in Pearl River, New York, reads, "Ridgewood, New Jersey. Bergen County. A part of the business district." (Author's collection.)

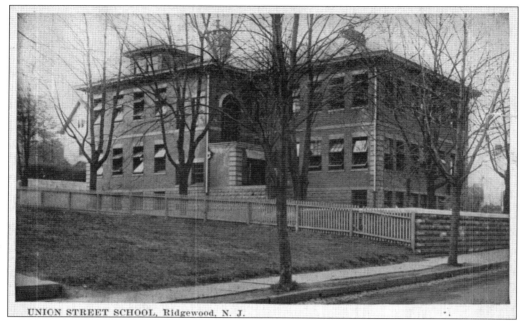

UNION STREET SCHOOL, Ridgewood, N. J.

Despite many logistical challenges, the Union Street School opened in 1905 and managed to keep its doors open for 61 years, finally closing in 1966. Home to one of the more diverse schools in Ridgewood, the building is remembered fondly by its remaining alumni, who have organized yearly reunions. In 2011, more than 30 showed up for a reunion at Van Nestle Park. Bob Puritz (a Union alumnus) purchased the building in 1973. The exterior remains largely intact, although the interior is now a mixed–use building. (Courtesy of the Ridgewood Historical Society.)

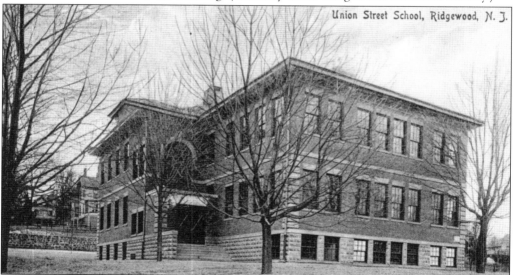

Union Street School, Ridgewood, N. J.

The class sizes at Union Street School were small (only about 20 students per class), but they made a large impact on anyone who attended the facility. Nancy Hayes Clune, now of Ashburnham, Massachusetts, was responsible for organizing the 2011 reunion, which coincided with the town's Fourth of July celebration. The school did not contain a cafeteria, so students walked home for lunch or brought their own. (Courtesy of the Ridgewood Historical Society.)

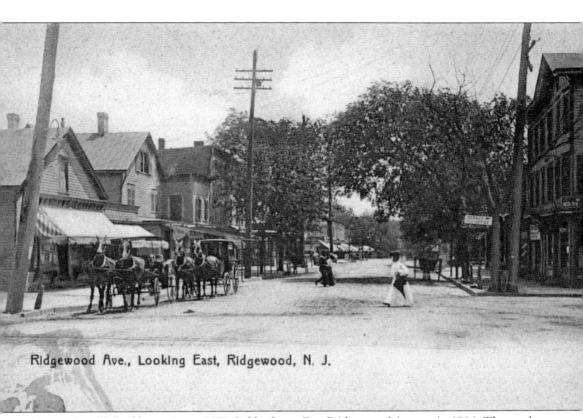

Ridgewood Ave., Looking East, Ridgewood, N. J.

This card, published by stationer E.W. Cobb, shows East Ridgewood Avenue in 1906. The roads are still dirt, and most traffic is still limited to horse carriages. The store on the right is the F.H. Adams Grocery, which stood next to the Lunch Room restaurant and the Hopper Building. Across the street are an estate store and a store with a banner proclaiming that it specializes in photographs. The front of the card reads, "Ridgewood Avenue, Looking East, Ridgewood, N.J." (Author's collection.)

Published by Dexter Press in 1948, this postcard shows the now-defunct Ridgewood Secretarial School. The school would close a short time later, after local colleges became coeducational. Addressed to Edwards Greaves of New Hampton, New York, this card was sent on November 6, 1948, at 9:30 a.m. The message reads, "Dear friend; I hope you had a good turnout at the dance and hopefully put you in as Master again. I will be back some time day soon with you all but I think of you all with love. Aunt Jesse." (Author's collection.)

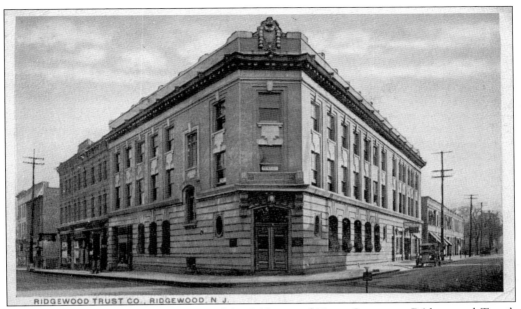

RIDGEWOOD TRUST CO., RIDGEWOOD. N J.

This 1910 postcard shows the offices of the Ridgewood Trust Company. Ridgewood Trust's New York correspondence was through Fidelity Trust Company. This card was addressed to Lucille Cornish on Broadway Street in Nynack [*sic*], New York. The text reads, "Hope you arrived home safely and that you are not going to stay away from Ridgewood too long. I am certainly 'enjoying' myself at school. You will get that candy one of these days as I always try to pay my debts. Have been at Possiak for a couple of days had a fine time. How is that 'burg' of Nynack? Your friend, Gene B." (Author's collection.)

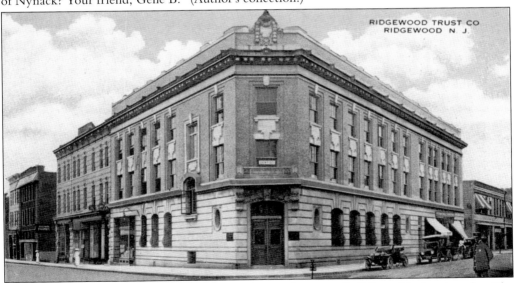

RIDGEWOOD TRUST CO
RIDGEWOOD N. J.

Shown a scant five years later is the Ridgewood Trust Company Building, this time in color. The yellowish tones of the building stand out amongst the gray of the business district. The company was organized in 1906 and in 1909 showed a total amount of allocated resources at $547,000. The trust company teamed up with the First National Bank Building to give Ridgewood its first "financial district." (Author's collection.)

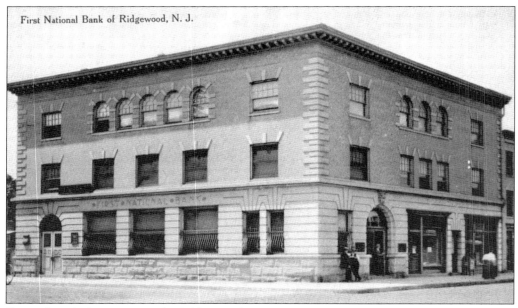

First National Bank of Ridgewood, N. J.

Shown here is the partner to the Ridgewood Trust Company, Citizen's First National Bank and Trust. Erected on Ridgewood Avenue in the 1930s, the history of this building is long and varied. A bank of some sort occupied the building until 2010, with Bank of America being the most recent financial tenant. In July 2015, Fish Urban Dining took over the bank portion of the building, installing an eatery in the location. (Courtesy of the Ridgewood Historical Society.)

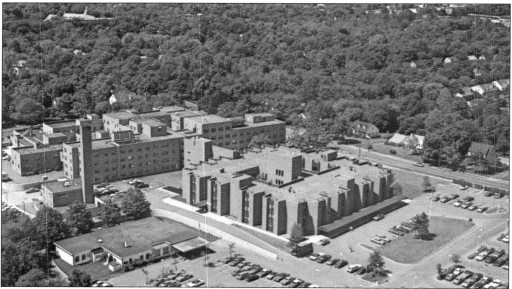

This photograph shows how Valley Hospital expanded upwards and outwards. Today, the Valley Hospital network includes five facilities in Ridgewood and neighboring Paramus and provides services for childbirth, cancer treatment, heart treatment, rehabilitation, child therapy, autism treatment, mobile intensive care, and others. The back of the card reads, "The Valley Hospital. Ridgewood, New Jersey 07451. A voluntary, nonprofit community hospital with 400 beds serving 16 communities of Northwest Bergen County." (Author's collection.)

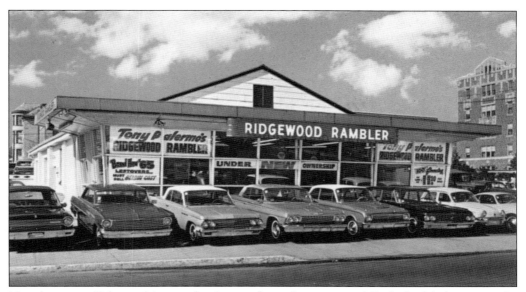

Now known as Palermo Motors, the site was formerly an automobile dealership known as the Ridgewood Rambler. Given that the Nash Rambler was only produced from 1950 to 1954, this postcard captures a unique part of the American obsession with automobiles. Despite the flashy colors and the fast cars, the business could not have lasted long: Nash Motors went bankrupt around the same time it stopped making the Rambler after 26 years in business. (Author's collection.)

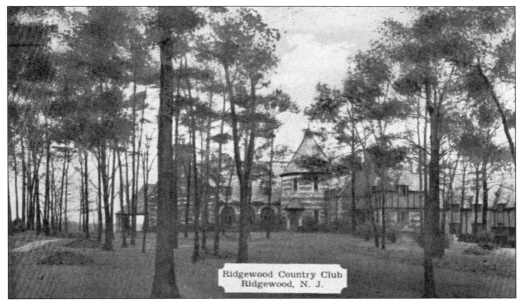

Although the club still carries the Ridgewood name, the Ridgewood Country Club has been in Paramus since 1926. Listed in the National Register of Historic Places in 2015, the grounds play host to 27 holes of golf. The course was designed by A.W. Tillinghast, and the clubhouse was designed by Clifford Wendehack. PGA Tour events such as the Barclays, the US Senior Open, and even the Ryder Cup have been played on its hallowed grounds. (Courtesy of the Ridgewood Historical Society.)

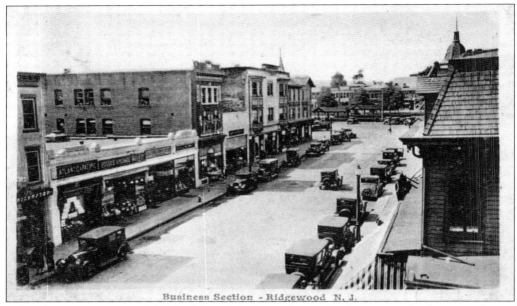

Business Section - Ridgewood N. J.

Taken between 1915 and 1930, this aerial views shows the downtown business section of Ridgewood. Model A sedans line the sides of the street. The Great Atlantic and Pacific Tea Company (A&P) store can be seen on the left side, and the platform for the Erie Railroad station can be seen in the distance. The front of the card reads, "Business Section–Ridgewood, N.J." (Courtesy of the Ridgewood Historical Society.)

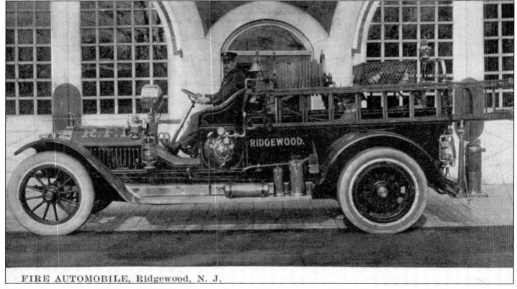

FIRE AUTOMOBILE, Ridgewood, N. J.

Taken between 1915 and 1930, this early card shows one of the first fire vehicles owned by the City of Ridgewood. The Ridgewood Fire Department came into existence in 1897 and has found its home at five locations: Hudson Street (1897–1910); Circle Avenue (1902–1940); Hudson Street again (1911–1993); West Glen Avenue (1947–present, currently serving as quarters for firefighters, offices, and equipment); and the current location at 201 East Glen Avenue, which was built in 1992. (Courtesy of the Ridgewood Historical Society.)

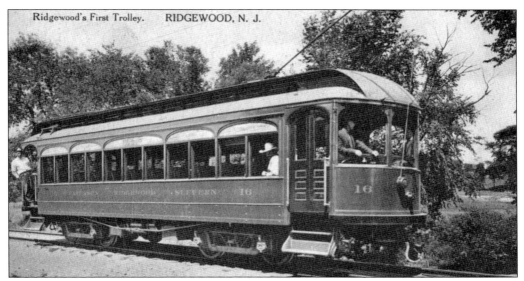

This postcard shows the first trolley from the North Jersey Rapid Transit Company (NJRT), which ran through the Ridgewood area from 1910 to 1928. The line served East Paterson, Fair Lawn, Glen Rock, Ridgewood, Ho-Ho-Kus, Waldwick, Allendale, Ramsey, Mahwah, and Suffern. The rise of both buses and the personal automobile doomed the trolley in Ridgewood, just as it did in many other places. The trolley runs stopped in 1928, and the responsibility for mass transit fell to the State of New Jersey. (Courtesy of the Ridgewood Historical Society.)

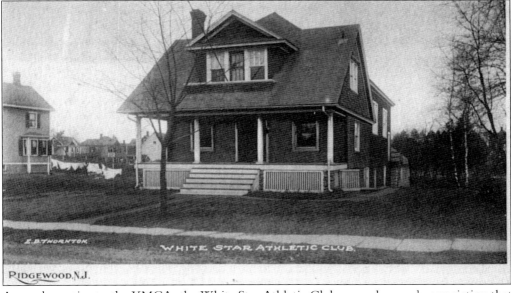

As an alternative to the YMCA, the White Star Athletic Club was a dues-only association that provided the Ridgewood community access to a gymnasium, bowling alley, billiards room, and parlors, among other amenities. Annual dues were $10, with an additional initiation fee of $5, putting membership out of reach for everyone save the most affluent of Ridgewood residents. In 1910, it was said to have 140 members, or less than three percent of the population. The front of the card reads, "White Star Athletic Club. Ridgewood, N.J.," and the card was produced by E.B. Thornton. (Courtesy of the Ridgewood Historical Society.)

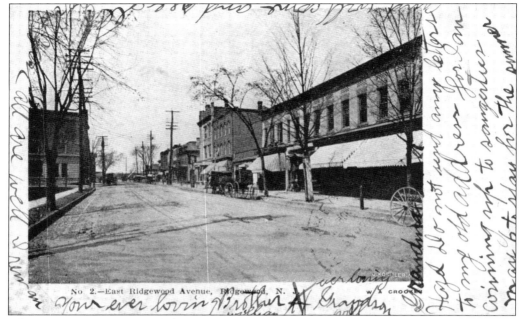

After 1898, private postcards became a cheap alternative to sending a full letter. Since only an address was allowed on the undivided back, one was forced to be creative when sending a message. Written over this downtown view of East Ridgewood Avenue's business district, the note on this postal states, "Grandma Hazel Do not send any letters to my old address for I am coming up to Saugerties May 6 to stay for the summer and will come and see all Hope you all are well I reman am your ever loving Brother William and ever loving Grandson Will." (Author's collection.)

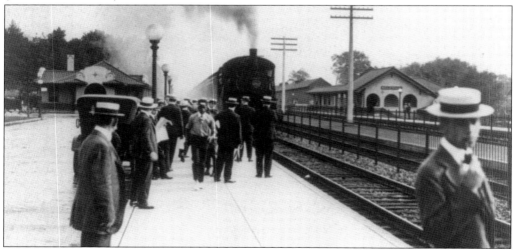

Despite its fierce independence, Ridgewood has played a large role in the business dealings of New York City, and it still does. This postcard shows a number of workers making this very journey. Today, there are two train routes to take into New York City (at a cost of almost $300 per month), along with a bus route and community bike share programs. If none of this works, one can always drive to New York—just think nothing of the gridlock and parking fees! (Courtesy of the Library of Congress.)

Four

Echoes of the Past
Ridgewood's Postal History

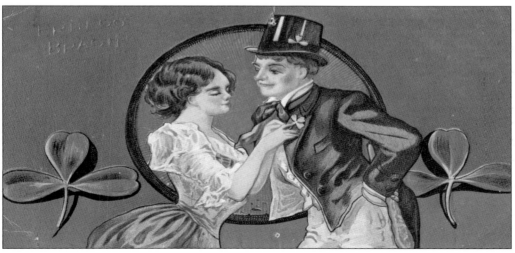

Per data released in 2013, Ridgewood has the largest concentration of people who claim Irish heritage in all of Bergen County. With 5,973 residents of Irish ancestry, Ridgewood's Irish community grew by 6.5 percent in a decade. This postal, mailed to Ridgewood on February 15, 1913, to Joseph Platz from South Bend, Indiana (home of the Notre Dame Fighting Irish), commemorates St. Patrick's Day. Patrick is a fifth-century Catholic saint who is said to have banished every snake from Ireland. He is the patron saint of Ireland. This card shows the anglicized Irish phrase "Erin go Bragh," usually translated as "Ireland Forever." (Author's collection.)

W 2 K Y H

Station _WILYW_ Date _11-21-39_ Time _4.45 AM EST_

Your Report _5-8_ Band _160_ Conditions

Xmitter _450 W ½ ant End feed_ Rcvr. **Comet Pro** _HQ-120_

Remarks _many tnx for card. Sorry you could not be heard on the west coast. Better luck next time. Pse send a_

P
QSL _card to W9CZN he wants one just mention my call_
E **17 Randolph Place** **David H. McIntyre**
W9CZN 70 Scott St chgo Chicago I'll you were hrd there me

RIDGEWOOD, NEW JERSEY

This ham radio postcard was sent from one amateur station operator (W2KYH) to another (WILYW). The card reports a test on November 21, 1939, during which the operator of the former could not be heard by the operator of the latter at 4:45 a.m. Despite the failure of the audio, the sender seems rather jovial as he discusses plans to listen to other stations nationwide. (Author's collection.)

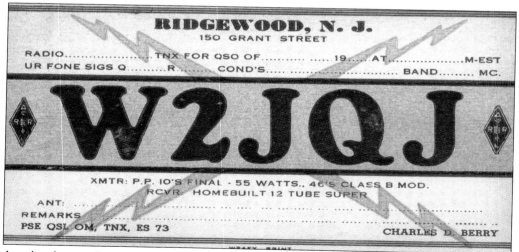

Another ham radio sample out of Ridgewood, this time by Charles E. Berry at 150 Grant Street, is the subject of this postcard. While the card is unused, Berry employed a 55-watt class B transmitter and a home-built 12-tube super receiver. Ham radio continues to be popular even today, as there are websites devoted to those who transmit and network in a manner highly reminiscent of the postcard traders of the early 20th century. (Author's collection.)

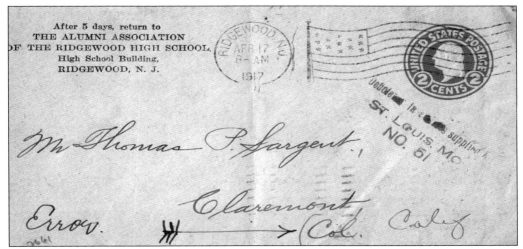

The alumni of Ridgewood High School scatter far and wide in their searches for success. Among their ranks are major-league baseball executives, professional eaters, conservative talk show hosts, and even a four-star general. This card, shipped on April 17, 1917, is addressed to Thomas P. Sargent, who had moved on from Ridgewood and made his way to Claremont, Colorado. The card is an invitation to a class reunion that was returned undelivered. (Author's collection.)

Apparently, playing sick at the turn of the century was a much tougher proposition than it is today. This unused, prepaid postcard appears to be designed for children (or, perhaps more likely, their parents) to give to their doctors when they were deemed too sick to attend school. The directions on the back of the card instruct the doctor to plug in the student's name, the date, and the condition that afflicted the poor student. Instead of returning the card to the family, it would be mailed straight to the school. (Author's collection.)

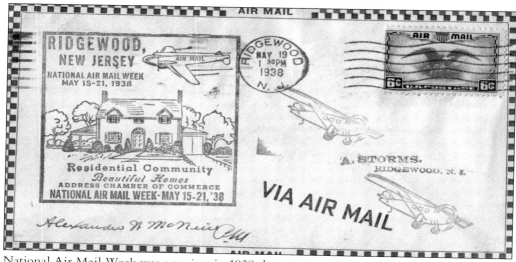

National Air Mail Week was a project in 1938 that set out to raise public awareness of airmail and its benefits to the citizens of the United States. The postal service had started using airmail in 1918 on a route between New York City and Washington, DC, but most Americans were not taking advantage of the service. The idea for the week was born as a potential boon to businesses near the end of the Great Depression. This letter was sponsored by the Ridgewood Chamber of Commerce and was sent on May 19 at 1:30 p.m. (Author's collection.)

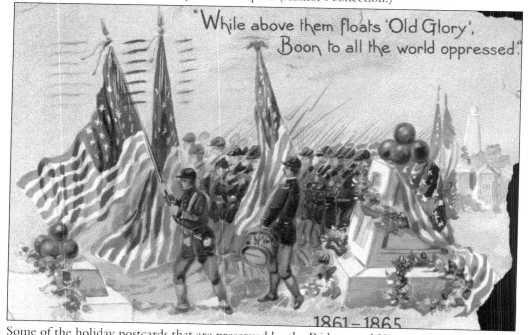

Some of the holiday postcards that are preserved by the Ridgewood Historical Society are less a reminder of the gaiety that surrounds a holiday and more a somber reminder of the sacrifices made so that others could celebrate. This turn-of-the-century sample is a reminder of the fresh hell that the United States fought through during the Civil War less than 40 years prior. The text on the card reads, "While above them floats Old Glory, Boon to all the world oppressed." (Courtesy of the Ridgewood Historical Society.)

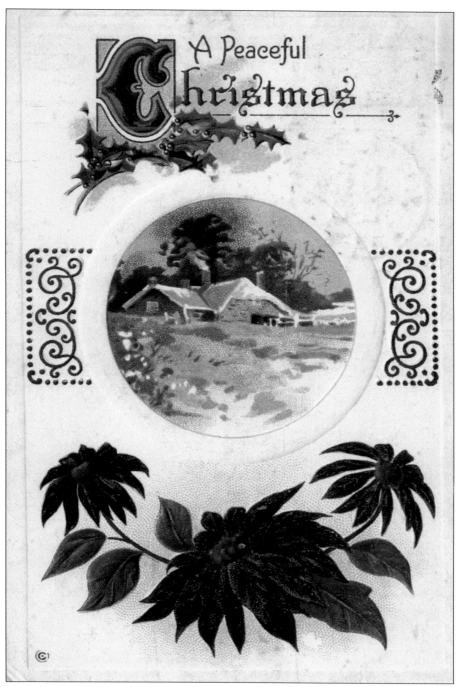

Decked with a snow-covered house and wreaths of mistletoe, this "A Peaceful Christmas" card is one of millions that have throughout history made their way in and out of Ridgewood. This one was addressed to Kate le Welch of 17 Circle Venue in Ridgewood. The message to Kate reads, "From cousin Ayra. With love and I wish you would come home." Thus, the adage that there is "no place like home" is expressed. (Author's collection.)

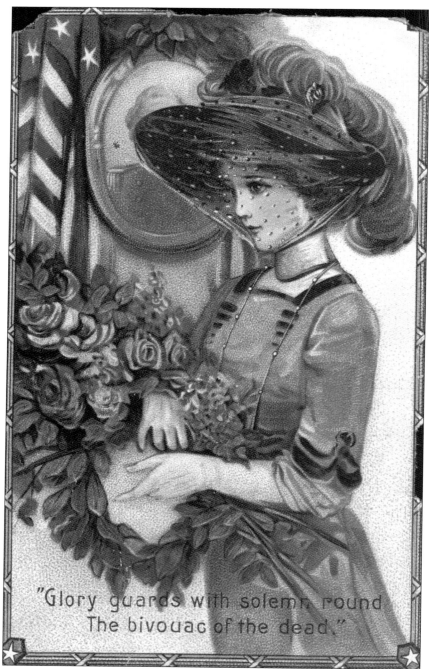

"Glory guards with solemn round
The bivouac of the dead."

Although the wreath and holly in the lady's hands gives the sense that this card was meant to be sent around Christmastime, the somber tone of the card serves as a reminder of the loss suffered by those at the holiday season. With her black veil, the American flag in the background, and the portrait of what appears to be a Union officer over her shoulder, one can only assume her beau never returned home. The front of the card reads, "Glory guards with solemn round the bivouac of the dead." (Courtesy of the Ridgewood Historical Society.)

Unlike today, where holidays such as Memorial Day and the Fourth of July are met with a parade of campers, boaters, swimmers, beer-busters, and partiers, these events in the past served as a solemn reminder of what had been fought for and what had been lost. Signed by artist Ellen H. Clapsaddle, this postal shows a small boy holding a wreath under dual American flags. At the top is a simple message: "Lest we forget." (Courtesy of the Ridgewood Historical Society.)

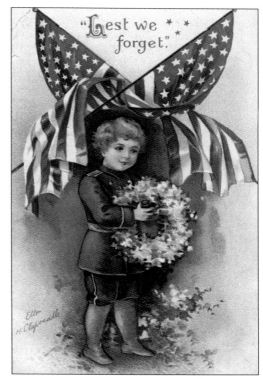

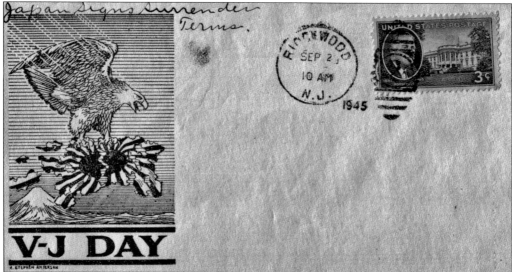

The deadliest war in human history came to its harrowing conclusion on September 2, 1945, with the signing of a peace treaty between the United States and Japan. On August 6, the United States became the only country in history to use nuclear weapons when it dropped an atomic bomb on Hiroshima. Three days later, an atomic attack followed on Nagasaki, followed by a Soviet declaration of war against Japan on August 10. Japan offered terms of surrender on August 15, and a peace treaty was signed on the date of this mailing, a mere 30 minutes before the 10 a.m. Ridgewood postmark. (Author's collection.)

A young couple is shown preparing to run Old Glory up a flagpole in honor of those lives lost in defense of the United States. The top of the cards reads, "Memorial Day." With a banner trailing that contains the motto appearing on the Great Seal of the United States as well as on money, *E pluribus unum* (Latin for "Out of many, one"), the poem at the bottom reads, "To day the thronging millions troop / Where floats that standard in their view, / And ours, dear Flag, the joy to stand / Beneath thee loyal to our Land." (Courtesy of the Ridgewood Historical Society.)

This January 27, 1971, mailing commemorates the centennial of the Fidelity Lodge of the Free and Accepted Masons in Ridgewood. The lodge traces its founding to Master Mason John Martin Knapp of Lodge No. 371 in New York City. Nobody knows for sure why he selected the name "Fidelity" for the lodge. The first lodge was in the upper room of a tavern in Ho-Ho-Kus. The lodge moved to Ridgewood in 1873 and has remained there since, although it would at various times find itself located in Ryerson Hall, the First National Bank Building, and at 99 South Maple Avenue, where it is today. (Author's collection.)

Unlike the somber days of remembrance, the New Year was often a time for celebration and dreams of life and goals anew. This 1912 postal shows Stephen J. Loekle (who was, it seems, well-off enough to have custom postcards printed with his own picture), dapper and ready for the New Year. The young 1913 shows the glorious work of art to the wizened, cranky 1912, who without a doubt is dismayed by the youthful vibrancy that the subject presents. (Courtesy of the Ridgewood Historical Society.)

The US Post Office Department expanded international postal service to Syria in 1947. As with many of its expansions, the postal service denoted the moment with a specially stamped airmail letter, distinguishable by its red and blue striped border. Sent by J.N. Clarkson to himself on July 23, 1947, this letter, given the current political climate, is a testament to America's willingness to interact with the rest of the world. Current circumstances unfortunately do not bode well for future mailings to the Middle East. (Author's collection.)

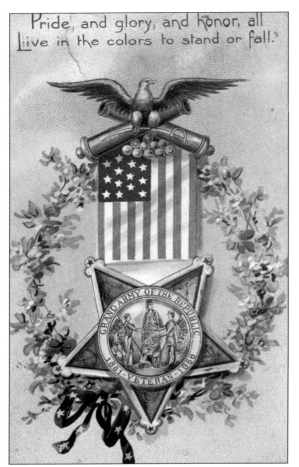

"Pride, and glory, and honor, all / Live in the colors to stand or fall."

This card is unique in the sense that it shows the medal awarded to veterans of the American Civil War (1861–1865), a fight for the freedom of men and the salvation of a nation's soul. It is easy to forget that this conflict cost more American lives than any other that the United States has been involved in, including both world wars. The card reads, "Pride and glory and honor, all / Live in the colors, to stand or fall." (Courtesy of the Ridgewood Historical Society.)

In 1949, the Post Office Department undertook its first flight to Switzerland, with a delivery destined for the alpine city of Zurich. Switzerland is famous for its world-class skiing as well as being the home of the Red Cross; Swiss businessman Henry Dunant organized locals to tend to soldiers wounded in aggressions between Austria and France in 1859. This led him to write a book about his experience and to formulate the idea for the Red Cross. Switzerland and the United States also have strong business ties, with the United States as the leader in free-market capitalism working in concert with Swiss banks. (Author's collection.)

On the brink of America's entry into the First World War (necessitated by the resumption of unrestricted submarine warfare and the Zimmermann Telegram, in which Germany sought to incite Mexico into war against the United States), William Tyler Page wrote the "American's Creed." Page, a descendent of John Tyler, America's 10th president, worked most of his life in Washington, DC, as a civil servant. Page submitted the poem to a contest designed to stir up patriotism; it would be adopted as the national creed by an act of Congress on April 3, 1918. (Courtesy of the Ridgewood Historical Society.)

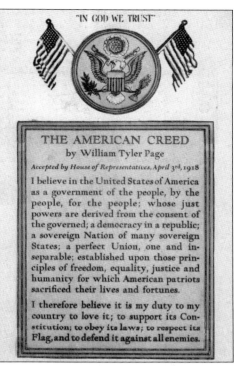

"IN GOD WE TRUST"

THE AMERICAN CREED
by William Tyler Page
Accepted by House of Representatives, April 3rd, 1918

I believe in the United States of America as a government of the people, by the people, for the people; whose just powers are derived from the consent of the governed; a democracy in a republic; a sovereign Nation of many sovereign States; a perfect Union, one and inseparable; established upon those principles of freedom, equality, justice and humanity for which American patriots sacrificed their lives and fortunes.

I therefore believe it is my duty to my country to love it; to support its Constitution; to obey its laws; to respect its Flag, and to defend it against all enemies.

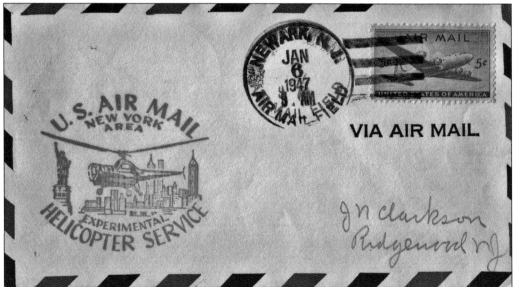

On January 6, 1947, the Post Office Department conducted extensive testing of the use of helicopters in airmail service. Landings and takeoffs took place in 39 sites in New Jersey, New York, and Connecticut, including Ridgewood. Over 100,000 pieces of mail were carried, although most were, like this letter, collectors' items sent to mark the occasion. So excited was the populace for the development that several children were excused from class for the event. Postmarked at the Newark airfield at 9:00 a.m., this letter was received in Ridgewood a mere two hours later. (Author's collection.)

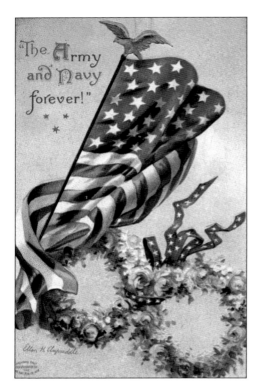

Ellen H. Clapsaddle made a career, it seems, out of illustrations for patriotic postcards. The examples provided here show her as in the vanguard of both the artistic stylings and the patriotic sentiments of yesteryear. This sample shows an American flag with a pair of wreaths shaped into an infinity symbol below. The text reads, "The Army and Navy forever!" (Courtesy of the Ridgewood Historical Society.)

Minnie B. may have had plans to mail this card, but given that this 1906 postal bears no postmark, it stands to reason that it never was sent, or that it was placed in an envelope and mailed, which completely defeats the purpose of a postcard. This card is decorated with the name Ridgewood Heights, which denotes the section above the ridge in town, where one can, on a clear day, see New York City in the distance. With privately made postcards becoming vogue in the era, additions like glitter, string, feathers, and even hair were common. (Author's collection.)

George Washington, America's first president and Revolutionary War hero, has plenty of ties to the Ridgewood area. The primary one is the use of the Old Reformed Church at Paramus as his headquarters three times during the engagement. Washington served as president from 1789 to 1797. He would survive, as this card shows, a little over two years after his term ended, dying on December 14, 1799, a mere 17 days before the start of the 19th century. (Courtesy of the Ridgewood Historical Society.)

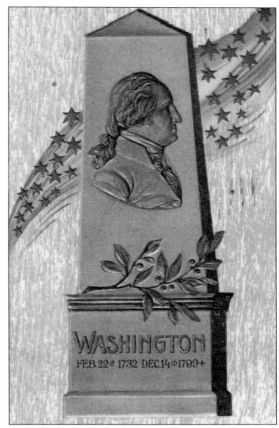

Ridgewood, to the surprise of no one, also celebrates Thanksgiving with all the trimmings. The village hosts an annual four-mile run that loops around Franklin Avenue, Kensington Street, and East Glen Avenue. It is sponsored by Freedom Bank, Consolidated Service Distributors, Kuiken Brothers, Excel, Applebee's, and Belmar Spring Water. The town also hosts an annual interfaith service, both in the spirit of Thanksgiving and to ring in the December holiday season. (Author's collection.)

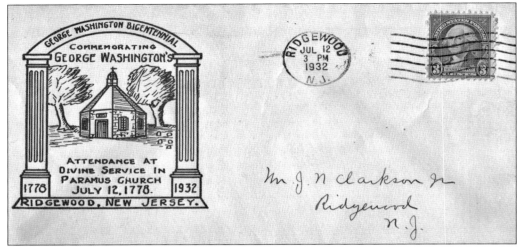

In 1932, the US Post Office Department took part in the celebration of the bicentennial of George Washington's birth. In the 200 years since, the nation had evolved from British colonies to a loosely affiliated group of states under the Articles of Confederation to a more perfect union under the Constitution. This article, mailed at 3:00 p.m. on July 12 to J.N. Clarkson Jr. of Ridgewood, bears a special stamp commemorating Washington's service attendance at Old Paramus Church on July 12, 1778. (Author's collection.)

The legacy of apartheid states in Africa even seems to have reached Ridgewood. In this 1937 mailing, one is greeted with a letter sent from the former British colony of Northern Rhodesia. Addressed to R. Hoekstra, this postal is odd in that there is no letter inside the sealed envelope. Northern Rhodesia merged with Southern Rhodesia and Nyasaland in 1953 and became what is now known as Zambia in 1964. In a rarity, this newfound independence led to Zambia being the only country to start an Olympiad under one flag and name and end it under another. (Author's collection.)

Although the landmark on the front of this postcard is not in Ridgewood, it is notable for who published it. Shown here is the Green Parrot Café, an establishment in Rochester, Minnesota, that was run for five decades by Edward H. Klopp. This card, however, was published by C.J. O'Brien, based in Ridgewood, in conjunction with AAA. Aside from postcards, O'Brien also published books, including 1951's *This is Ridgewood: A Handbook*, in conjunction with the League of Women Voters of Ridgewood, New Jersey. (Author's collection.)

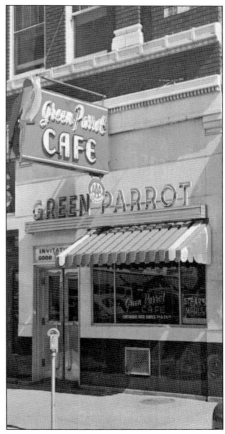

The history of the post office in Ridgewood is not all roses. On October 10, 1991, former postal employee Joseph M. Harris went on a murder spree that shook the upscale Ridgewood community to its core. Harris killed Carol Ott, a postal supervisor, and her boyfriend, Cornelius Kasten Jr. He then traveled to the post office and shot two clerks, Joseph M. VanderPaauw and Donald McNaught. Harris was sentenced to death in 1992, although he died in 1996 before the sentence was carried out. Today, a statue stands in front of the post office in memory of the victims. (Courtesy of the Ridgewood Historical Society.)

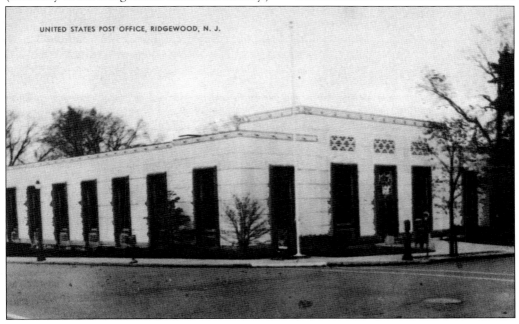

UNITED STATES POST OFFICE, RIDGEWOOD, N. J.

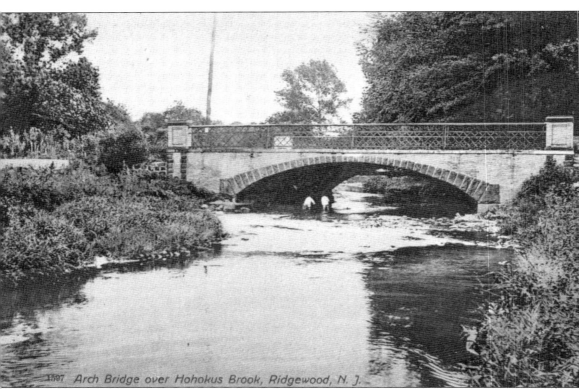

Arch Bridge over Hohokus Brook, Ridgewood, N. J.

Ridgewood started life under several names. The first names were Hochaos (Ho-Ho-Kus) and Paramus; both would go on to be the names of adjoining towns. Later, the Paterson & Ramapo Railroad would build a station in the town, naming it Godwinville. The locals, however, would hardly stand for that. The Dayton family led the charge for the town to change its name, and, after forming the town's post office, they finally managed to change the name to Ridgewood in 1865. The Erie Railroad followed suit, changing the name of the station to Ridgewood the next year. (Courtesy of the Ridgewood Historical Society.)

Five

NEW JERSEY LEISURE
RELAXING VIEWS FROM HOME

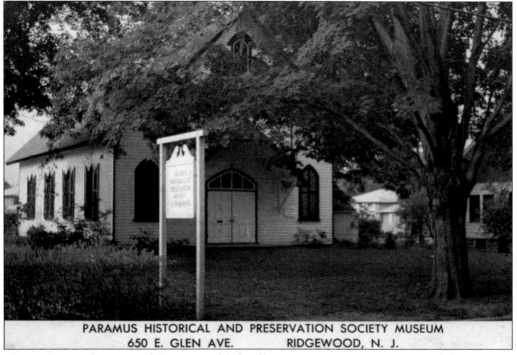

PARAMUS HISTORICAL AND PRESERVATION SOCIETY MUSEUM
650 E. GLEN AVE. RIDGEWOOD, N. J.

The Ridgewood Historical Society and Schoolhouse Museum was once part of the Paramus Historical Society's holdings. In fact, if one looks at the collection of postcards that the historical society currently holds, many are marked with the former's name and dates. Today, the tree in the foreground of this postcard is gone, replaced by a sign promoting the Ridgewood Historical Society. Dacey Latham currently serves as the society's president. (Courtesy of the Ridgewood Historical Society.)

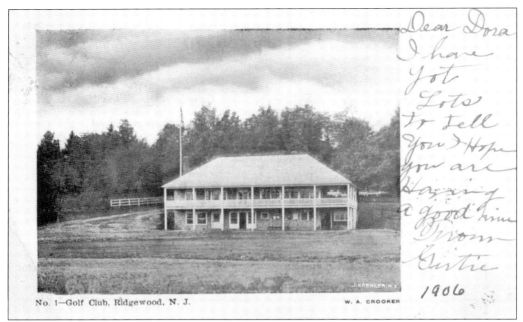

No. 1—Golf Club, Ridgewood, N. J.　　　　　　　　　W. A. CROOKER

Although now located in Paramus, the Ridgewood Country Club still considers Ridgewood home. The course provided 27 beautiful holes for golfers of all stripes; this 1906 postcard shows the original clubhouse. The text reads, "Dear Dora I have got lots to tell you I hope you are having a good time From Girtie," with "1906" written in blue ink. The publishing marks list W.A. Crooker as the postcard printer and J. Koehler of New York as the photographer. (Author's collection.)

This 1930s postcard shows what is now the location of Graydon Pool, which serves the entire community. Regular season for the pool runs from June to August with (weather permitting) a late season that runs until the end of September. Citizens can purchase a daily or yearly pass and can also purchase passes to the adjacent tennis courts. The pools offer swimming passes, yoga classes, and even story time. (Author's collection.)

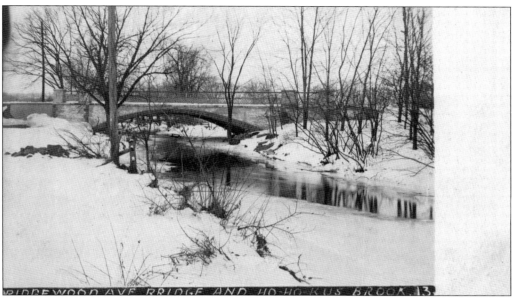

This 1907 postal shows Ridgewood Avenue and a bridge over Ho-Ho-Kus Brook blanketed in a layer of the white stuff. Ridgewood's northern Jersey location, combined with the effect of the nearby Atlantic, can wreak havoc on the weather patterns in the area. Ridgewood averages four inches of snow a month during December, January, February, and March, and the record low was set at -16 degrees on January 22, 1961. (Courtesy of the Ridgewood Historical Society.)

Although sponsorship and theme may change from time to time, Ridgewood has a continuous tradition of holiday parades that stretch back to the time before even the automobile or the postcard. This color postcard was produced by Pendor Natural Color of Pearl River, New York. The back text on the card reads, "Ridgewood, New Jersey. Bergen County. A Holiday Parade." (Author's collection.)

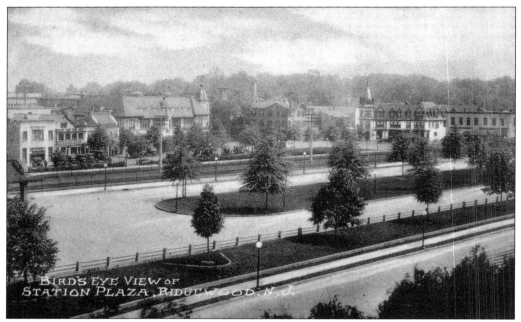

Although photography had not evolved enough for aerial views to be economic, artists' portrayals still were a popular, economical way of bringing overhead shots to the postal masses. This card, published by E.W. Cobb, shows an overhead view of the Erie Station Plaza in Ridgewood. Just like on much of the East Coast, mass transit's importance cannot be understated. The front of the card reads, "Bird's Eye View of Station Plaza, Ridgewood, N.J." (Author's collection.)

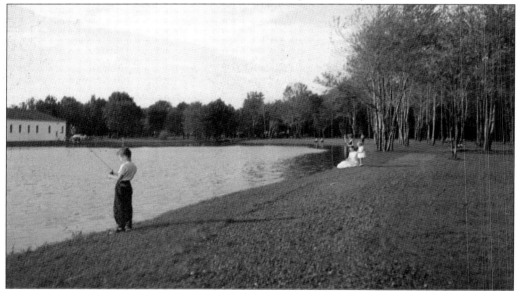

Formed by a small inflow and a small outflow into the Saddle River, the duck pond in Ridgewood has always been a special place for youth to feed the wild waterfowl that use the pond along their migration trail. The pond is a small part of the Saddle River Park, which also holds the Ridgewood Dog Park and several miles of hiking trails. Fishing is allowed in both the river and the pond, but a New Jersey fishing license is required. (Author's collection.)

This 1907 postcard shows a youth on a rowboat on Baldwin's Pond in Ridgewood. Given its location along the northern Atlantic seaboard, Ridgewood is blessed with a rather temperate climate. The warmest month of the year, July, only averages 84 degrees. Such weather makes the area perfect for fishing, sailing, and other spring and summer activities that can be enjoyed by young and old alike. (Courtesy of the Ridgewood Historical Society.)

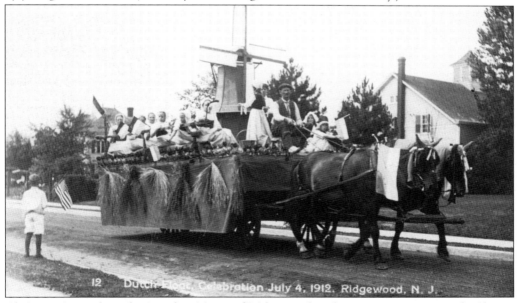

Christmas is not the only time the citizens of Ridgewood are known to put on a parade. Shown here in 1912 is a Dutch-themed float that was entered in the annual Fourth of July parade. While religion was more important amongst the Dutch at the turn of the century, it is less so now; in 2015, just 42 percent of people in the Netherlands claimed a religious affiliation. The front of this card reads, "12 Dutch Float. Celebration July 4, 1912. Ridgewood, N.J." (Author's collection.)

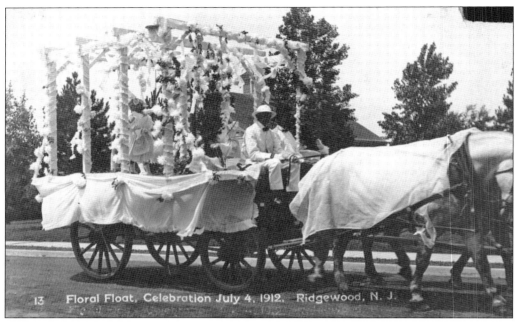

13 Floral Float, Celebration July 4, 1912. Ridgewood, N. J.

Given that New Jersey calls itself "the Garden State," it should come as little surprise that a floral float would be featured in the town's Fourth of July celebration over 100 years ago. Abraham Browning, himself a farmer, gave the state its moniker in 1876 when describing how New York and Pennsylvania tended to gobble up all the state's agricultural bounty. The name was cemented in 1954 over the objections of Gov. Robert Meyner. The state today is only 17 percent farmland and has the second-highest land cost per acre among the 50 states. (Courtesy of the Ridgewood Historical Society.)

This 1972 postcard depicts the entire state of New Jersey, wide open and waiting for adventurous travelers to begin their journeys. Several historical landmarks, along with a notation of every state park in New Jersey, are contained on this map, which also displays New Jersey's state flower (the violet) and state bird (the goldfinch). In the upper right corner is Ridgewood, wedged between State Routes 203 and 17, the Garden State Parkway. (Author's collection.)

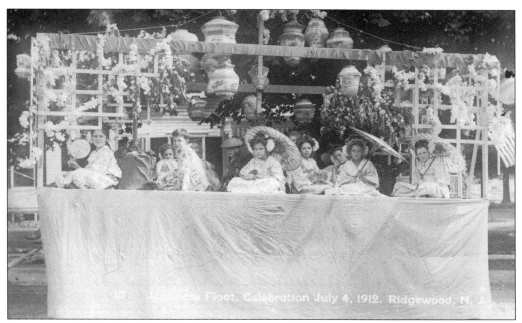

Although cultural appropriation was a way of life over a hundred years ago (notice the smiling white faces in kimonos on this postcard), today, nearly 15 percent of the population of Bergen County, where Ridgewood resides, is of Asian descent, per the figures in the 2010 Census. The Asian population increased a whopping 34 percent between 2000 and 2010, with those of Chinese descent being the fastest-growing group. (Courtesy of the Ridgewood Historical Society.)

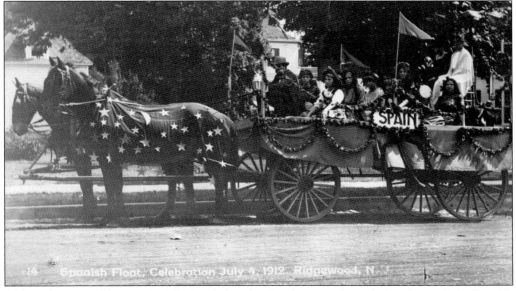

Although one could argue (and fairly so) that the float here was intended to show off the Spanish population in the area, the dark skin and flamboyant dress are more aligned with those of Hispanic or Latin American descent. Per the 2010 Census, Hispanics of any nationality make up a little over 16 percent of the population in the area and are the second-largest ethnic group in Bergen County. (Courtesy of the Ridgewood Historical Society.)

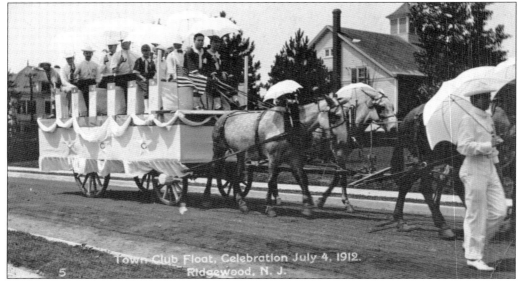

The greatest amount of civic pride during these festivities went to the float belonging to the Town Club of Ridgewood. The Town Club holds special significance, as Pres. William Howard Taft gave a public address on the steps of its veranda on May 25, 1912. This was the first presidential visit to the Ridgewood area. Taft, after losing the presidency in a four-way race with Teddy Roosevelt, Woodrow Wilson, and Eugene Debs, became chief justice of the US Supreme Court in 1921. (Courtesy of the Ridgewood Historical Society.)

Not a park in a traditional sense, Kathawood Park is rather a real estate development with its roots in the turn of the century. Developed by Fred C. Robbins, the streets within the park find their names rooted in Native American lingo; for example, there are streets names Kemah Road, Waiku Road, and Wastena Terrace. The front of this card, published by stationer E.W. Cobb, reads, "Entrance to Kathawood Park, Ridgewood, N.J." (Author's collection.)

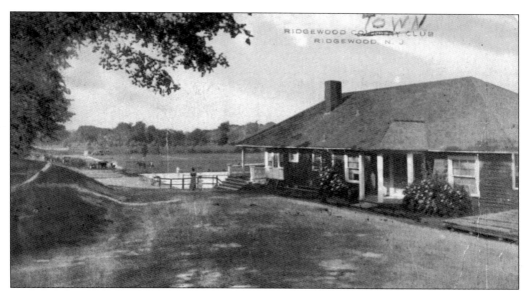

Dating back to 1890, the golf course at Ridgewood Country Club is one of the more prestigious on the East Coast. The site holds its share of awards: it was ranked No. 73 by *Golfweek* magazine in 2005 and No. 83 by *Golf Magazine* in 2009. It is the original home course for PGA legend Byron Nelson. The club has hosted its fair share of events, including the Ryder Cup (1935), the Senior PGA Championship (2001), and the Barclays, which is the first round of the FedEx Cup (2008, 2010, and 2014). (Courtesy of the Ridgewood Historical Society.)

THIRD JUDICIAL DISTRICT COURT
OF BERGEN COUNTY

RIDGEWOOD, N. J., June 17th, 191 1.

The following case on list for Tuesday

June 20th, 1911.

Standard Oil Co. --vs-- Motor Shop of Ridgewood.

Yours truly,

J. B. Salisbury

Clerk.

This card, addressed to attorney F.W. Van Blarcom (who served in the New Jersey Legislature from 1902 to 1904 for Passaic County, as county counsel for Passaic County in 1924, and as chairman of the Passaic County Republican Party in 1922), summons the attorney to a case in the Third Judicial District Court of Bergen County in Ridgewood on June 17, 1911. Although most likely a simple case of past-due debt, this was not the only case in 1911 involving Standard Oil: On May 15, the US Supreme Court, in a 9-0 decision, decided to break up the trust that was Standard Oil in response to New Jersey's antitrust claims. (Author's collection.)

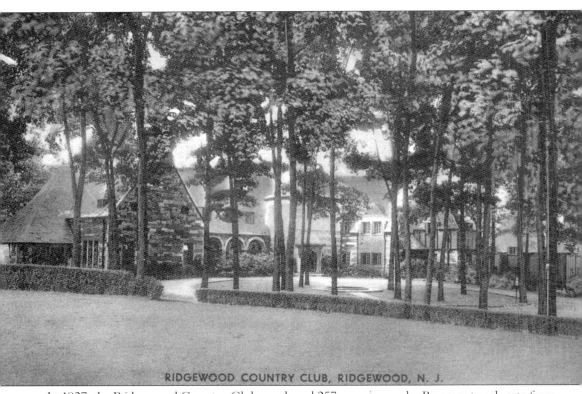

RIDGEWOOD COUNTRY CLUB, RIDGEWOOD, N. J.

In 1927, the Ridgewood Country Club purchased 257 acres in nearby Paramus to relocate from its original 1890 site. A.W. Tillinghast was brought on to design the new course, which his children later claimed was his personal favorite. The new location opened with much fanfare on May 30, 1929. Tillinghast is considered one of the greatest golf course designers of the 20th century. (Courtesy of the Ridgewood Historical Society.)

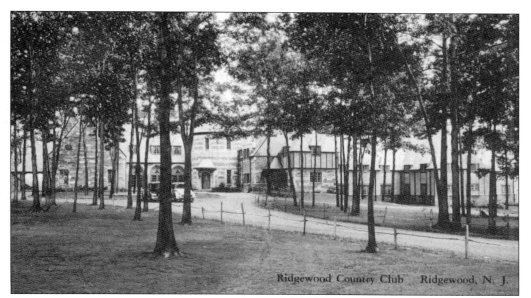

Ridgewood Country Club Ridgewood, N. J.

As important as the course itself, the clubhouse, constructed between 1927 and 1929, is vital to the Ridgewood Country Club experience. Clifford Charles Wendelhack, an architect from Upper Montclair, was tapped to design the building, which, given the similarities between Northern New Jersey and Normandy, France, was built in the Norman Revival style. The Ridgewood Country Club today takes an active role in restoration and preservation of the site. (Courtesy of the Ridgewood Historical Society.)

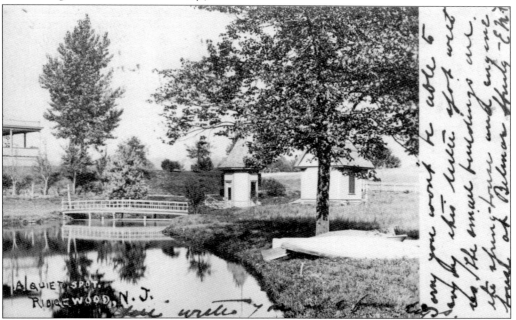

A QUIET SPOT. RIDGEWOOD, N. J.

This 1906 card shows, as the front says, "A Quiet Spot. Ridgewood, N.J." The message on the card reads, "Sorry you won't be able to enjoy this water job with us. The small buildings are the spring-house and engine house at Bulman Spring. E.M.F." This summertime view is one of many that show the enjoyment of the local waterways in Ridgewood. (Author's collection.)

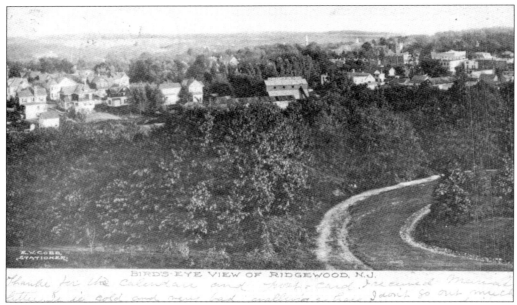

BIRD'S-EYE VIEW OF RIDGEWOOD, N.J.

Taken from the Heights, the image on this card by stationer E.W. Cobb shows another overview of Ridgewood. Addressed to Mrs. Aaron L. Stevens of South Norwalk, Connecticut, this card was sent on November 14 of some unknown year after 1907. The message on the back reads, "Letters just received. So very sorry around Ma. I have quiet time for letter now will write you to-night. I'll be up Saturday or Sunday any may alone. Love to you all. Ruth goes to-morrow to school. Zelda." (Courtesy of the Ridgewood Historical Society.)

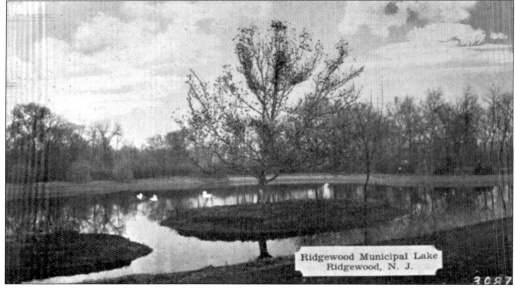

Ridgewood Municipal Lake
Ridgewood, N. J.

This image shows not the duck pond but Ridgewood Municipal Lake, which is now a part of the Graydon Pool complex. The complex is bordered by North Maple Avenue to the west, Linwood Avenue to the south, Northern Parkway to the east, and Meadowbrook Avenue to the north. Ho-Ho-Kus Brook, a tourist spot, runs through the park as well, and the Ridgewood Public Library is visible nearby. (Author's collection.)

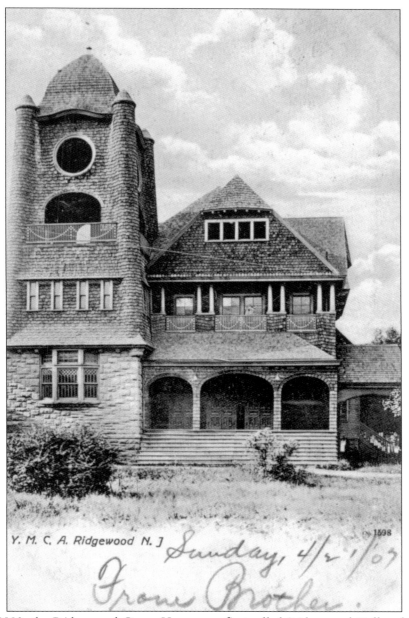

Y. M. C. A. Ridgewood N. J.

Built in 1893, the Ridgewood Opera House was first called Ridgewood Hall and was built through community donations. The building was surrounded by Ridgewood Avenue to the north, Prospect Street to the west, Dayton Street to the south, and Oak Street to the east. William E. Stone of New York City designed it, but local contractors were used for all phases of its construction. Eventually, it would become a movie hall, home to the fire bell and, for a short stint, the location of the YMCA. Addressed to a Mrs. Rodgers, care of J.B. Bloom in Lynn, Massachusetts, the message on the back of this card reads, "J.M.L.A. Ridgewood, NJ. This is where I spend most of my time. Glad to hear from you, thanks for the post card from ME. I may see you again in Sept. Luck coming my way another vacate of a week and a half. T.W. Billings." (Author's collection.)

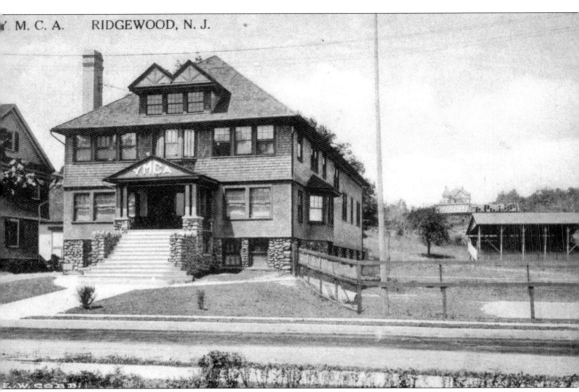

This 1911 image shows the opera house as the YMCA. The Ridgewood YMCA was established as a nonprofit in 1844 to serve the needs of young men in the area, with facilities for sports, exercise, and swimming. Today, the YMCA has expanded into three Ridgewood locations: the executive office at 55 North Broad Street, the Oak Street Branch at 112 Oak Street, and the Camp Bernie Branch at 327 Turkey Top Road in Port Murray. (Author's collection.)

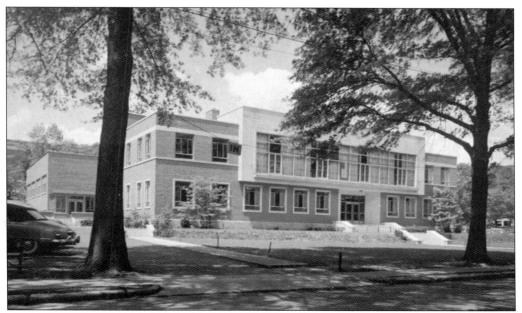

In 2016, the Ridgewood YMCA found itself with a new chief executive officer. Ernest Lamour came to Ridgewood after a long and adventurous journey that began with his birth in the impoverished city of Port-au-Prince, Haiti, the site of the first successful slave rebellion in the Western world. Having immigrated to the United States at a young age, Lamour lived in Stamford, Connecticut, for most of his life and became involved with the YMCA when his hometown facility closed. His position allows him to lead a YMCA outreach program to his nation of birth. (Courtesy of the Ridgewood Historical Society.)

Welcome to

The Bolger Heritage Center
Ridgewood Public Library

www.ridgewoodlibrary.org
125 North Maple Avenue, Ridgewood, NJ 07450
201-670-5600 x135

HeritageCenter@ridgewoodlibrary.org

The research of Ridgewood history extends beyond the wealth of resources available from the Ridgewood Historical Society. This modern postal advertises the Bolger Heritage Center at the Ridgewood Public Library. With a large collection of antique photographs, maps, and postcards, the Bolger Heritage Center offers both roots for genealogical research and a glimpse into the area's past. On the reverse of this card, a nod to the modern is given, as the reader is invited to connect with the group on various social media platforms. (Author's collection.)

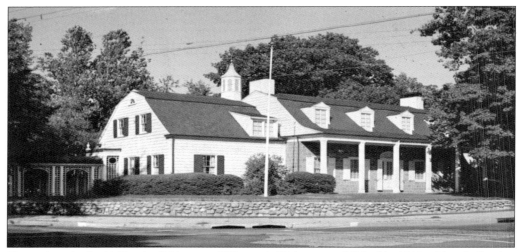

Shown here in the 1920s, the Ridgewood Women's Club was established in 1909 with a dedication to social and civil engagement by women on all levels. This card shows the clubhouse, built in 1928, shortly after its completion. In 1910, the club became affiliated with the New Jersey Federation of Women's Clubs, which oversees 228 clubs and 12,000 members throughout the state of New Jersey. (Author's collection.)

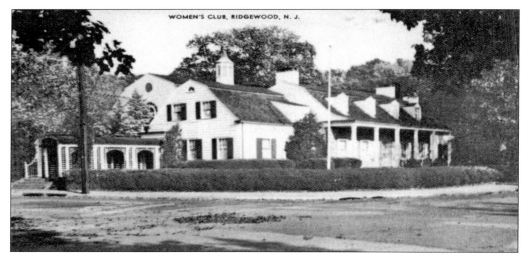

The Ridgewood Women's Club also belongs to the General Federation of Women's Clubs, which today claims over 100,000 members across the United States. Its purpose, as stated on its website, is fourfold: to bring women together; to achieve personal growth; to work for the benefit of children, senior citizens, and those in need; and to offer women of all ages an opportunity to exchange ideas and form lifelong friendships. (Author's collection.)

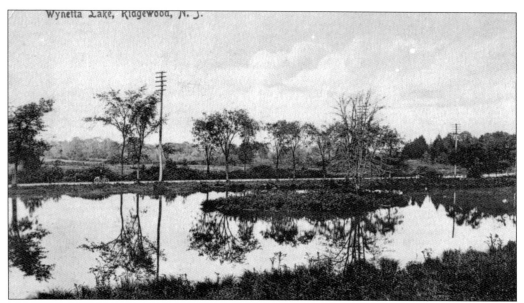

Wynetta Lake, Ridgewood, N. J.

Published by stationer E.W. Cobb, this postcard shows Wynetta Lake along Paramus Road in Ridgewood. Given that the back is divided, this is a card that Cobb printed after 1907, but as the card has never been used, there is little in the way of information about its history. Wynetta Lake is one of the several lakes, ponds, and streams that form from the Saddle River, and Paramus Road now runs through the city of Paramus and all the way up to the Ridgewood line. The area, it seems, was popular for camping. (Author's collection.)

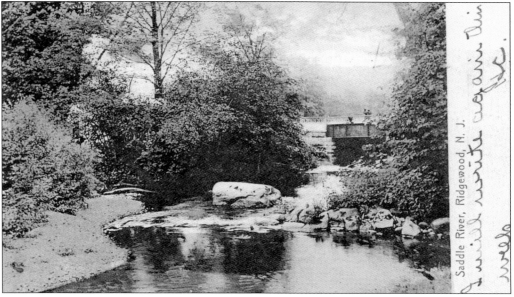

The Saddle River runs through much of Bergen County. Shown here in a hand-colored card from 1907, the text reads, "Saddle River, Ridgewood N.J.," and the writing reads, "I will write again this week. H.C." The river takes its name from the River Saddell in Argyll and Bute, Scotland. Although most of the river is in New Jersey, its headwaters are in Rockland County, New York. (Author's collection.)

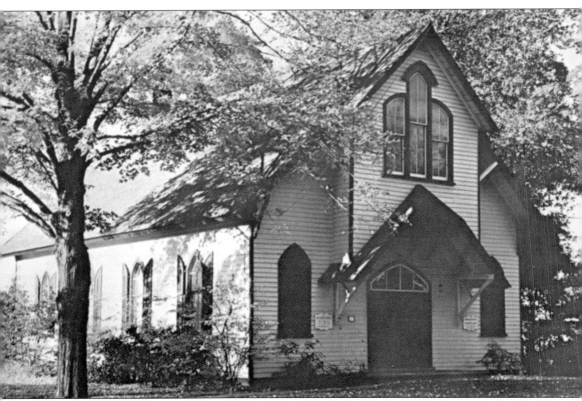

This card shows the Schoolhouse Museum, a part of the Ridgewood Historical Society. The back of the card reads, " 'Headquarters of the Paramus Historical and Preservation Society', 650 East Glen Avenue. Present building built in 1873 and used until 1905, is the 5th school organization under the supervision of the Old Paramus Reformed Church since 1730. Features original school equipment, room settings, local Indian artifacts and some nationally important relics: also a reference and genealogical library." (Courtesy of the Ridgewood Historical Society.)

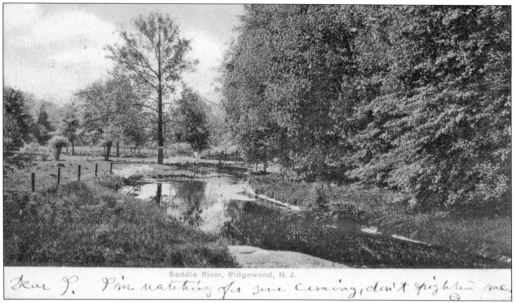

This uncolored 1907 postal gives another glimpse of the Saddle River. The text on the back reads, "Saddle River, Ridgewood NJ. Rouclere House, Ridgewood, New Jersey," with an unreadable signature. The river, all of 17 miles long, feeds into many ponds and tributaries along its route, stories of which are recounted in this book. (Courtesy of the Ridgewood Historical Society.)

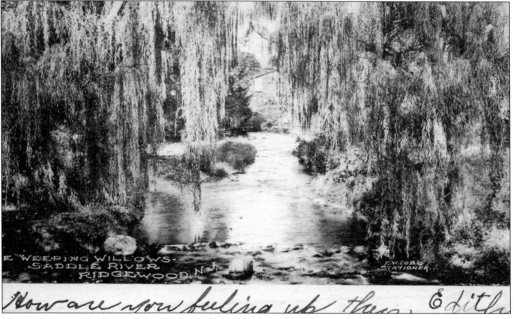

Shown here are the beautiful weeping willows that dot the banks of the Saddle River in Ridgewood. Published by stationer E.W. Cobb, the front of this card reads, "The Weeping Willows. Saddle River, Ridgewood, N.J.," and the handwriting reads, "How are you feeling up there. Edith." The Saddle River empties into the Passaic River. (Author's collection.)

This postcard, published by stationer E.W. Cobb, shows the three bridges that cross the various waterscapes along East Ridgewood Avenue. What makes this card stand out is the amount of virgin farmland and pastureland that dots both sides of the landscape, with wildflowers in full bloom. At various points, bridges cross the Saddle River, Ho-Ho-Kus Brook, and several other small tributaries and creeks along East Ridgewood Avenue. (Author's collection.)

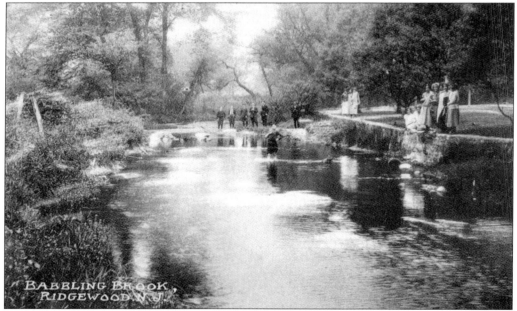

This 1907 postcard gives a view of a low-water, stone-filled portion of Ho-Ho-Kus Brook in Ridgewood. Although considered a part of the Greater Saddle River, the brook does not actually meet the river until it reaches the Dunderhook area of Saddle River County Park. The front of this card reads, "Babbling Brook, Ridgewood, N.J." (Courtesy of the Ridgewood Historical Society.)

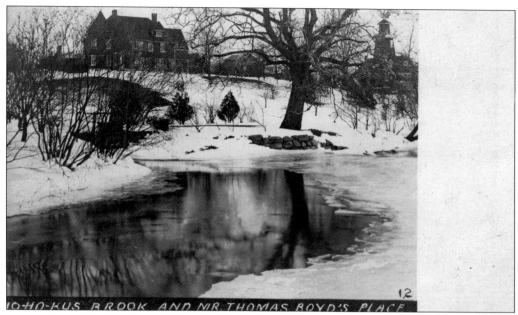

IO-HO-KUS BROOK AND MR. THOMAS BOYD'S PLACE

Postmarked June 7, 1909, this card shows what was known as Boyd's Raceway below the Ridgewood Avenue Bridge, on the Ho-Ho-Kus Brook. This card, like many others in this collection, was published by stationer E.W. Cobb. The flowers are in bloom in this view, and, with most of the rapids covered, one can assume that the years preceding 1909 were rain-filled and lush. The front of the card reads, "Ho-Ho-Kus Brook and Mr. Thomas Boyd's Place." (Author's collection.)

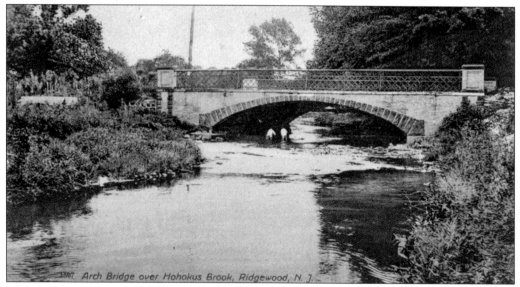

Arch Bridge over Hohokus Brook, Ridgewood, N. J.

This image, with two children under the bridge, presumably fishing, wading, or treasure hunting, shows one of the many bridges over the Ho-Ho-Kus Brook in Ridgewood. This lush, hand-colored card shows the pure joy of the summer months, with greenery lining both sides of the riverbank. The front of the card reads, "Arch Bridge over Hohokus Book, Ridgewood, N.J." (Author's collection.)

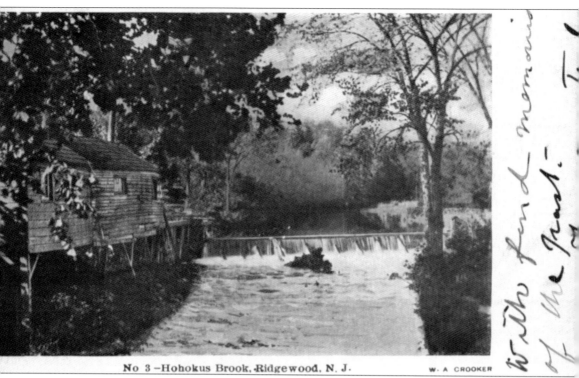

No 3 —Hohokus Brook, Ridgewood, N. J.

W. A CROOKER

Shown here at Overbook Road is the famous Ho-Ho-Kus Brook of Ridgewood and Bergen County. The confluence of the brook and Saddle River marks the border of four Bergen County communities: Ridgewood, Glen Rock, Fair Lawn, and Paramus. It also marks the border between Mahwah and Wyckoff. Ho-Ho-Kus Brook passes through the New Jersey villages of Mahwah, Franklin Lakes, Wyckoff, Allendale, Waldwick, Ho-Ho-Kus, Ridgewood, and Glen Rock. It is not specified which mill is shown in the photograph but it could be Rosencrantz Cotton Mill, Brookdale Bleachery, or the paper mill owned by White & Co. The lower left corner of the photograph notes "E.W. Cobb Stationer." (Author's collection.)

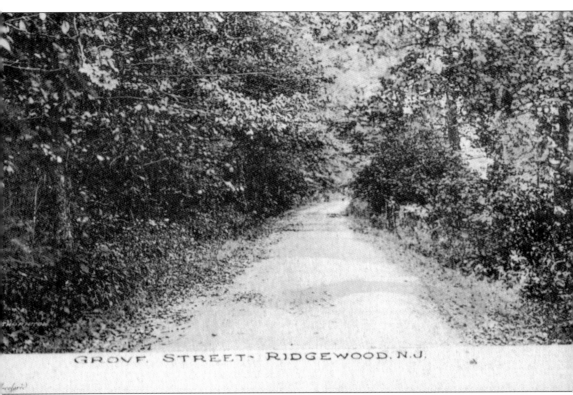

GROVE STREET · RIDGEWOOD, N.J.

Grove Street is one of the many roads in Ridgewood that cross both the Saddle River and Ho-Ho-Kus Brook before they converge. The two bodies of water meet up in Grove Park, and each is home to several species of fish, including largemouth bass, pickerel, bullhead catfish, sunfish, and several varieties of trout. (Courtesy of the Ridgewood Historical Society.)

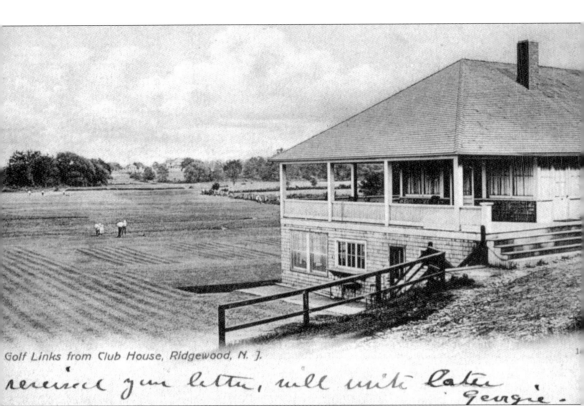

Golf Links from Club House, Ridgewood, N. J.

received your letter, will write later . Georgie .

The links at the Ridgewood Club (shown here) are world-class and have played host to many top-level championships. There are also plenty of other golfing opportunities available in the area. The Orchard Hills Golf Course, the Paramus Golf Course, the Hackensack Golf Club, and the Emerson Golf Club are all nearby. The text on the front of this card reads, "Golf Links from Club House. Ridgewood, N.J.," and the message reads, "I received your letter. Will write later. Georgie." Georgie must have had a date with the links, because he or she couldn't even be bothered to respond in a proper way to a letter. (Courtesy of the Ridgewood Historical Society.)

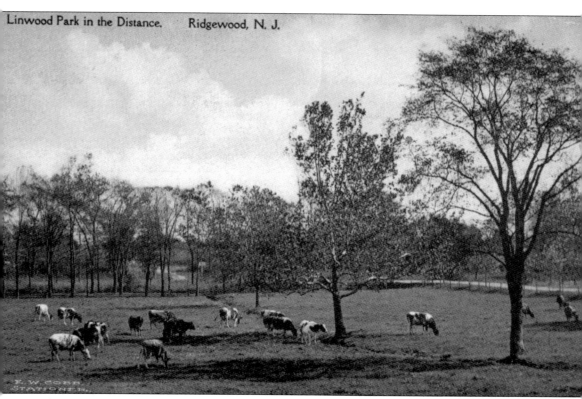

Linwood Park in the Distance. Ridgewood, N. J.

As the cows graze gently in the foreground, one is directed to the view of Linwood Park in the distance. Published by famed local stationer E.W. Cobb, this card shows the duality of country living: the agrarian lifestyle that birthed a nation combined with the leisure of the burgeoning bourgeoisie at the turn of the 20th century. Linwood Park was dedicated in 1910 as a part of an Arbor Day celebration and was the beginning of the Ridgewood Parks system. The front of the card reads, "Linwood Park in the Distance, Ridgewood, N.J." (Courtesy of the Ridgewood Historical Society.)

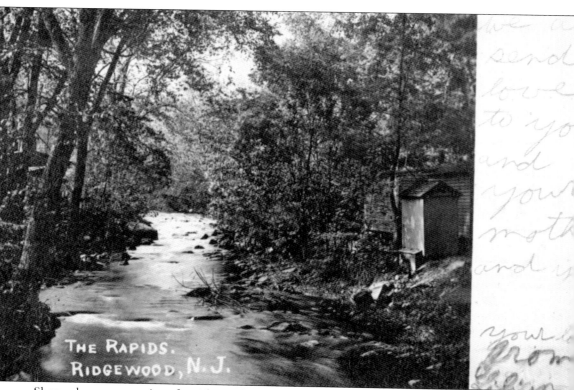

Shown here are a series of rapids on the Ho-Ho-Kus Brook in Ridgewood. The current on the Ho-Ho-Kus makes it ideal for several species of sport fish as well as swimming, canoeing, kayaking, and other water sports. The text reads, "The Rapids, Ridgewood, N.J.," and the handwriting on the back reads, "The rapids remind us of Frenchtown. Al. Michael. Pie." This card was produced by Tower Manufacturing Company in New York and dates to before 1907. (Author's collection.)

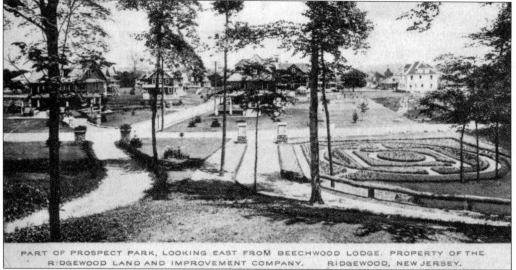

PART OF PROSPECT PARK, LOOKING EAST FROM BEECHWOOD LODGE. PROPERTY OF THE RIDGEWOOD LAND AND IMPROVEMENT COMPANY. RIDGEWOOD, NEW JERSEY.

Not a park in a historical sense, but rather a blooming real estate development, the beginnings of the Prospect Park area that straddles Ridgewood and Glen Rock are shown in this postal. Most of the homes are of the Colonial Revival variety, and the area has been suggested, by both Ridgewood and Glen Rock, as a national historic district. The front of this card reads, "Part of Prospect Park, Looking East from Beechwood Lodge. Property of the Ridgewood Land and Improvement Company. Ridgewood, New Jersey." (Courtesy of the Ridgewood Historical Society.)

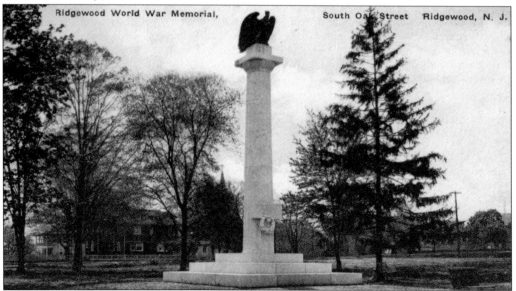

Ridgewood World War Memorial, South Oak Street Ridgewood, N. J.

The Ridgewood Veterans Memorial lies in Van Nestle Square along East Ridgewood Avenue. Designed by New York sculptor John Oscar Bunce, this monument features a three-stepped granite base, a granite plaque of names, and a laurel wreath. A tall, fluted granite column extends skyward, and, atop it is perched a bronze eagle. The monument was installed in 1924 and primarily serves as a memorial to those who died in the First World War. (Courtesy of the Ridgewood Historical Society.)

DISCOVER THOUSANDS OF LOCAL HISTORY BOOKS
FEATURING MILLIONS OF VINTAGE IMAGES

Arcadia Publishing, the leading local history publisher in the United States, is committed to making history accessible and meaningful through publishing books that celebrate and preserve the heritage of America's people and places.

Find more books like this at
www.arcadiapublishing.com

Search for your hometown history, your old stomping grounds, and even your favorite sports team.

Consistent with our mission to preserve history on a local level, this book was printed in South Carolina on American-made paper and manufactured entirely in the United States. Products carrying the accredited Forest Stewardship Council (FSC) label are printed on 100 percent FSC-certified paper.

MADE IN THE USA